LAKE BLUFF
—— 1895-2020——

LAKE BLUFF

—— 1895-2020 ——

CELEBRATING 125 YEARS
FROM SUMMER RESORT TO SUBURBAN REVIVAL

KATHLEEN O'HARA

AMERICA
THROUGH TIME®
ADDING COLOR TO AMERICAN HISTORY

America Through Time is an imprint of Fonthill Media LLC
www.through-time.com
office@through-time.com

Published by Arcadia Publishing by arrangement with Fonthill Media LLC
For all general information, please contact Arcadia Publishing:
Telephone: 843-853-2070
Fax: 843-853-0044
E-mail: sales@arcadiapublishing.com
For customer service and orders:
Toll-Free 1-888-313-2665

www.arcadiapublishing.com

First published 2021

ISBN 978-1-63499-319-7

Typeset in 10pt on 12pt Sabon
Printed and bound in England

ACKNOWLEDGMENTS

This book would not have been written without the collaboration, support, and advice of Lyndy Jensen of the Lake Bluff History Museum, who was the partner through all aspects of this process, providing the technical and layout expertise necessary to complete this project. Her diligence, eye for detail, and adherence to a definite timeline has allowed for the successful completion of this book.

This book of Lake Bluff history is dedicated to Janet Nelson, friend and mentor, who has played such a prominent role in the development of the village for over fifty years as teacher and principal of Lake Bluff School District 65 from 1969 to 2006; co-founder and archivist of the Lake Bluff History Museum; president of the Lake Forest High School District 115 Board of Education; and as chair of the Lake Bluff Historic Preservation Commission. Special thanks to Julie Grant and Pam Russell for their suggestions and editorial assistance and to Philip Ross for the cover photograph.

No book about Lake Bluff could be written without acknowledging the importance and significance of Elmer Vliet (1897–1994) to both the story and preservation of village history. Mr. Vliet came to Lake Bluff in 1927 as a chemist at Abbott Laboratories. He rose to chairman of the Board of Directors. Vliet served as a village trustee and village president, along with other local offices. In the 1930s, he began researching local history and collecting artifacts and photos from the earliest days of Lake Bluff. It is his collection that forms the foundation of the Lake Bluff History Museum today. Lake Bluff owes a lasting debt to Elmer Vliet for his dedication and foresight in the preservation of its heritage.

CONTENTS

INTRODUCTION

Lake Bluff was incorporated as a village in 1895 as its popularity as a Methodist camp meeting site and summer resort began to fade, primarily due to adverse economic conditions in the United States. As things sometimes go in Lake Bluff, its waning popularity was not without controversy. The Lake Bluff Camp Meeting Association had previously provided municipal services, such as street, sidewalk, and lighting maintenance. Mounting expenses, and the threat of annexation by neighboring Lake Forest, made the idea of incorporation attractive, although some residents were concerned about ensuing municipal taxes. On September 21, 1895, a local election was held, and voters decided that a village government was essential for the community's future.

For 125 years, since that affirmative vote for incorporation, the village of Lake Bluff, situated 32 miles north of Chicago on the shores of Lake Michigan, has grown and flourished. The village has received recognition in several local and national publications for being one of the Chicago area's best places to live, and its numerous community events have made it a desirable place to visit. So how did a sleepy little dot on the map, which originally only came alive during the summer months, evolve into a sought-after and admired place to live, work, and play? The chapters in this book will unfold Lake Bluff's story, which also mirrors the history of the United States during the same time period.

A New Beginning in a New Century (1895–1920)

In her 1889 autobiography, renowned temperance advocate Frances Willard wrote of Lake Bluff: "This beautiful spot on the sunset shore of Lake Michigan ... [is] famous as the chief rallying place of the Temperance leaders on this continent."[1] However, by 1895, the Lake Bluff Camp Meeting Association, which was founded in 1875 by a group of Methodists seeking a scenic summer location for their activities, was diminishing in popularity. In general, fewer organizations, including the national Prohibition Party of which Frances Willard was a prominent leader, congregated there in the summer months.

Lake Bluff was well-suited to be a popular summer resort, located just 32 miles north of Chicago, along the bluffs overlooking Lake Michigan, with its picturesque ravines and proximity to the railroad that ran from Chicago to Milwaukee. The Lake Bluff Camp Meeting was greatly influenced by the Chautauqua movement of the late nineteenth century, incorporating many of its ideas to bring cultural, educational, and recreational activities to the masses in rural and semirural locations.

Uncertain and volatile economic conditions across the country, and the threat of annexation by neighboring Lake Forest, among other factors, led to declining interest in the camp meeting. As a result, some year-round residents sought to incorporate Lake Bluff as a village to continue some of the functions previously handled by the association.

In 1894, six homeless children were removed from the streets of Chicago and brought by Methodist deaconesses to live in a small cottage located on what is now Scranton Avenue. This was the foundation of what was to become known as the Lake Bluff Children's Home. By the time it dissolved in the late 1960s, thousands of children had been housed, fed, and educated in a complex of buildings that spanned an entire block of the village. This was an era in Lake Bluff of social responsibility—assisting those deemed less fortunate—that included the creation of boarding houses and camps for the working women and children from the city.

With the coming of the interurban electric rail system in the early 1900s, the village was poised to grow concurrently with the expansion of the North Shore as an attractive

and accessible destination for young families seeking housing options outside Chicago. Several well-known Chicago millionaires built lakefront mansions bordering what is now Moffett Road, and a rather bohemian enclave was established near Sunrise Avenue and Park Lane. In the years prior to World War I, artists, writers, and poets gathered to avail themselves of Lake Bluff's charm and be inspired by its unspoiled beauty.

With the United States' entry into World War I, Lake Bluff, like so many other small villages and towns across the country, geared up for the conflict. From a population of around 700, seventy-eight men enlisted to serve.[2] Local women set up a branch of the American Red Cross at the Village Hall to do their part and support the war effort. The community raised $40,000 for the Third Liberty Loan, and additional funds were collected so Lake Bluff could send an ambulance and local driver to serve at the battlefront in France. As a result of these actions, the *Chicago Tribune* declared Lake Bluff to be the most patriotic town of its size in the United States.[3] The village also received a commendation from the French Government for its ambulance donation.

After the war and transition to peacetime, Lake Bluff began to evolve into an attractive community for young families seeking a suburban alternative to city life.

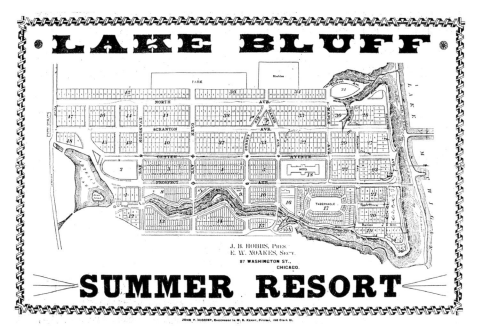

This *circa* 1895 map shows what is now the east side of Lake Bluff. James Hobbs was the president of the Lake Bluff Camp Meeting and also ran a real estate agency selling undeveloped lots in the village.

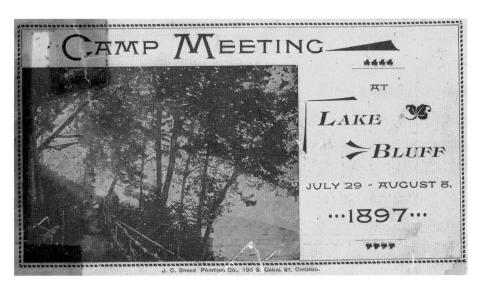

Every year from 1876, the first year of the Lake Bluff Camp Meeting, the association published a brochure highlighting the events and activities of the summer season. This advertises the summer of 1897, which turned out to be the last year the brochures were published. The burning of the Hotel Irving in May 1897 hastened the demise of the camp meeting.

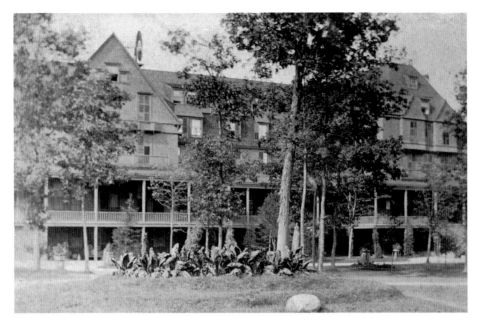

The Hotel Irving, erected in 1883, occupied an entire block—now the 500 block of East Prospect and East Center Avenues. The hotel was five stories high, with a promenade, ballroom, bowling alley, tennis courts, and a fountain—all the amenities that one would find in a modern-day resort. An additional feature was running water in all the guest rooms, which was almost unheard of in the 1880s. The water came from wooden pipes that ran from Artesian Lake, down Prospect Avenue to the hotel. The Irving was the largest hotel between Chicago and Milwaukee, could sleep 500 guests, and was the social center for the Lake Bluff summer resort visitors. It burned down in 1897.

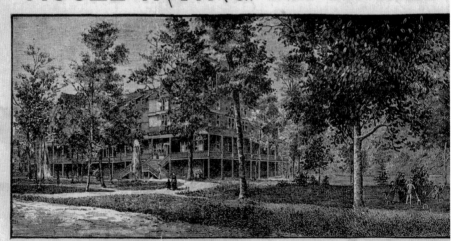

HOTEL IRVING. LAKE BLUFF. ILL.

HOTEL AND IMPROVEMENT CO., PROPRIETORS. MANAGERS : J. IRVING PEARCE, Sherman House, J. B. HOBBS, C. W. LASHER. CHICAGO.

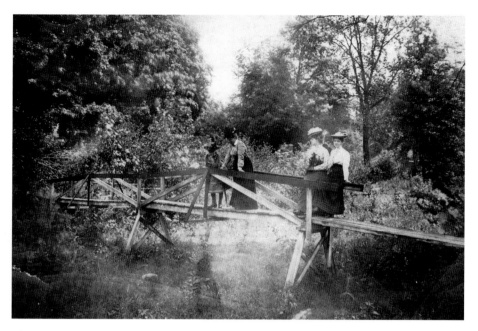

This postcard *circa* 1900 shows four well-dressed women crossing a wooden bridge over one of the many ravines in Lake Bluff. The ravines were one attraction that brought vacationers to the camp meeting and resort during its heyday from 1875 to 1900. Although the photo was taken during the summer, everyone is fully and fashionably dressed as befitted a middle-class matron of the period.

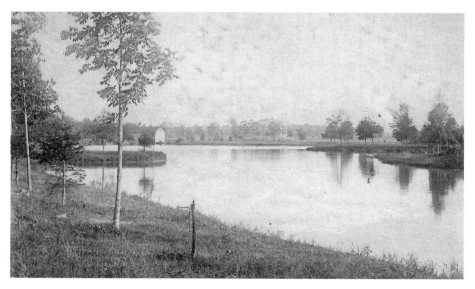

This photo shows Artesian Lake, which was created in 1883 by opening-up a well. The lake spread over 10 acres, stretching from the current baseball field across from the Lake Bluff Middle School to a point past the gazebo on the village green. There was swimming and sailing in the summer and ice skating during the winter months.

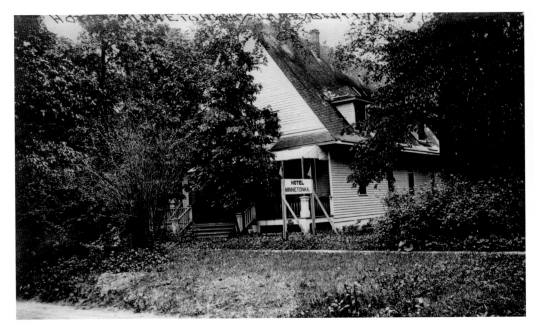

The Hotel Minnetonka, known as "the Working Women's hotel," was designed by famous Chicago architect Louis Sullivan in 1894 for working women from Chicago to visit and enjoy the ravines and beaches of Lake Bluff. It was referred to by the locals as the "Honeymoon" hotel because of its close proximity to a secluded pathway that led directly to the sandy shoreline.

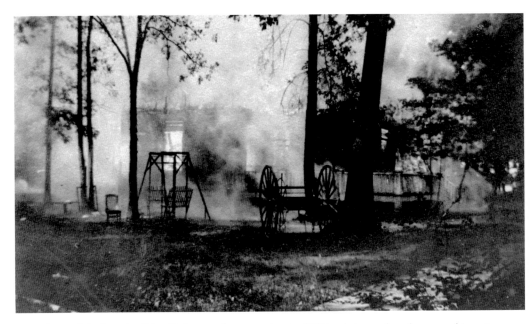

This photo of the burning Hotel Minnetonka was taken in 1917 as it burned to the ground in spite of efforts by our volunteer fire department to save the structure. The hotel stood on the northwest corner of what is now North Avenue and Moffett Road.

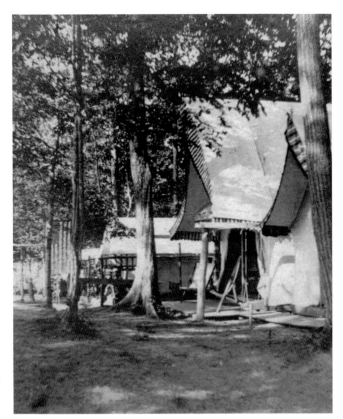

Right: This image, *circa* 1890, shows tents pitched on the bluff overlooking Lake Michigan. Tents were another lodging option provided by the Lake Bluff Camp Meeting Association. Guests could rent fully equipped tents, located on the bluff a short distance from where most of the events and activities took place; this was an ideal housing option for many visitors.

Below: This recently discovered photograph captured a wedding ceremony conducted on the camp meeting grounds *circa* 1890.

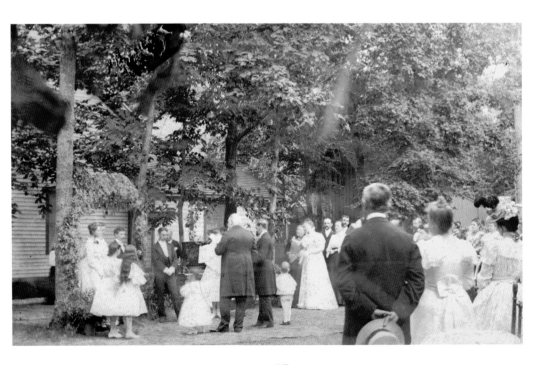

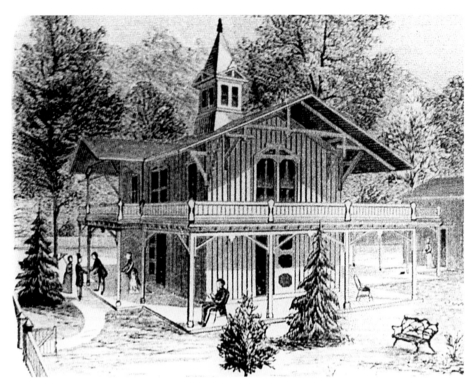

This artist rendering of the Solomon Thatcher cottage as it appeared in the 1877 *Annual*, advertising the type of cottages that could be built upon request.

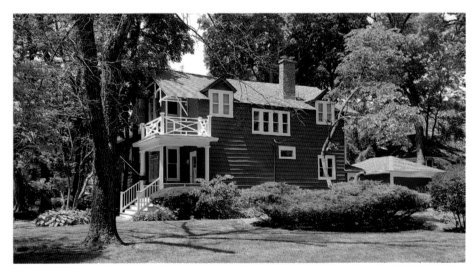

This 1876 cottage, built for Solomon Thatcher, one of the founders of the Lake Bluff Camp Meeting Association, served as a model for the type of cottages that could be built for $250 in twenty days on 25-foot lots. The design is called stick architecture—a popular cottage style of the period. It still stands at 344 East Prospect Avenue.

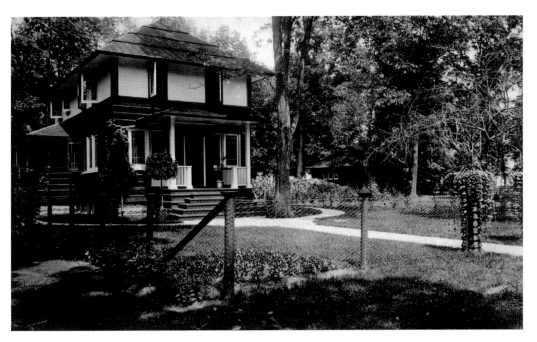

Built in the early 1900s, "Jungle Nook," home of John Howard, was one of the first prairie-style homes built in the village. It was designed by Webster Tomlinson, the business partner of Frank Lloyd Wright. He also was the architect for the Lake Bluff Village Hall in 1905.

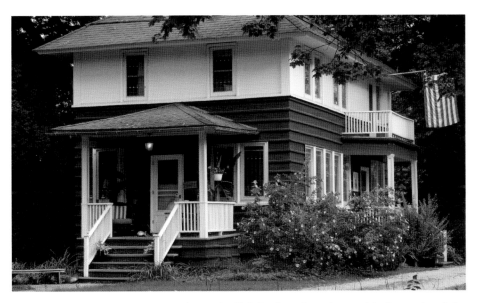

710 East Prospect as it appears today, only slightly altered on the outside from when John Howard had it built. The side lawn was expansive and had an unobstructed view overlooking the lake. Howard hosted the famous "Pink Rabbit" Balls, a popular summer favorite of the young people of the village.

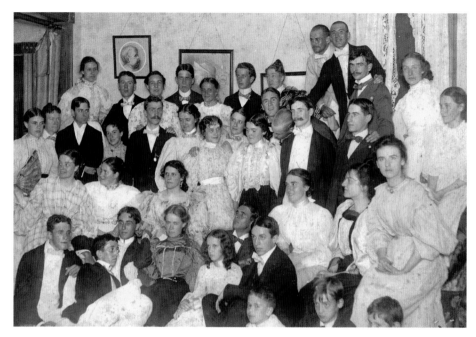

Pictured here are members of "the Kelly Klub," known for their carefree antics and lighthearted spoofing; they were a group of local youths and summer visitors who set the social tone for the younger set. For several years in the late 1890s, the club sponsored the "Pink Rabbit Ball" to which young ladies were invited to the dance.

The Pink Rabbit Ball was revived over a century later by the Lake Bluff History Museum. This 2011 photo shows long-time local residents, Peg and Kurt Gronau, dressed up for the ball.

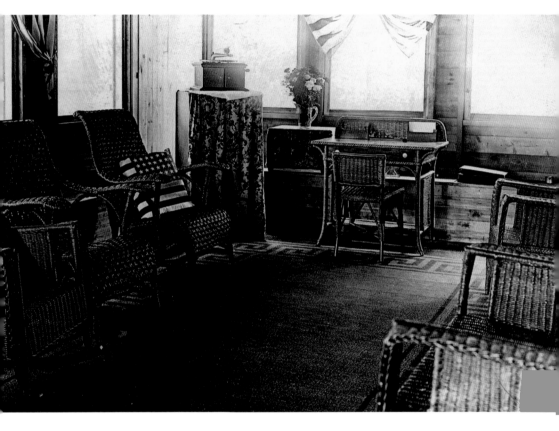

This is the only photograph the Lake Bluff History Museum has of an interior view of one of the summer cottages. It was taken around 1895 and most probably depicts a living room. Notice the phonograph in the corner and the American flag pillow. The furniture is wicker, which was so very popular in the Victorian Era.

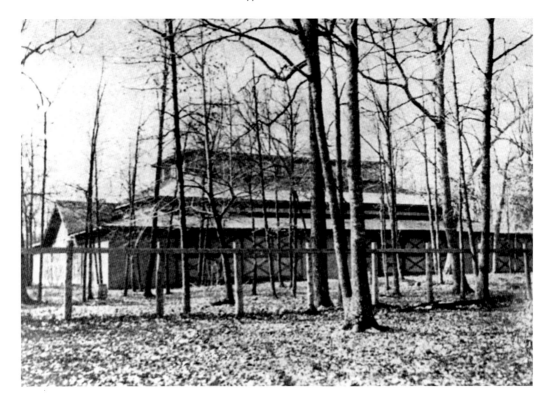

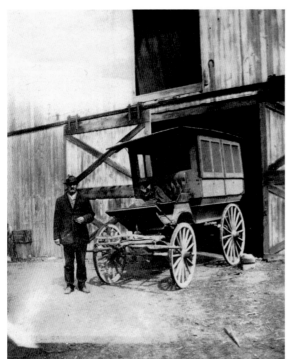

Above: The Lake Bluff Camp Meeting tabernacle, originally a tent, became a wooden structure in 1883, which could hold 2,500 guests.

It was used for religious ceremonies, lectures, and classes for both camp meeting and Chautauqua events. However, as interest in the camp meeting waned and the village was incorporated (1895), the tabernacle lost relevance and was torn down in 1899.

Left: Here is Mr. Flint, a well-known figure around town in the early 1900s with his livery taxi. He is standing in front of the livery barn, which was located behind 500 North Avenue. The barn was built using lumber from the demolished tabernacle.

Right and below: This photo, *circa* 1880, shows the Lake Bluff Camp Meeting Association's office, located on the grounds near the tabernacle. The building played host to the many dignitaries and guests who visited the camp meeting during its heyday. After the association was disbanded, the office was moved to what is now 500 North Avenue and became a private residence.

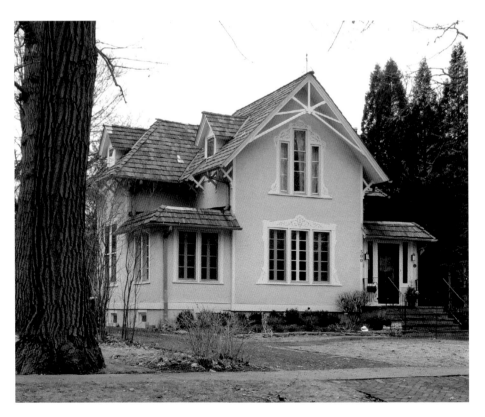

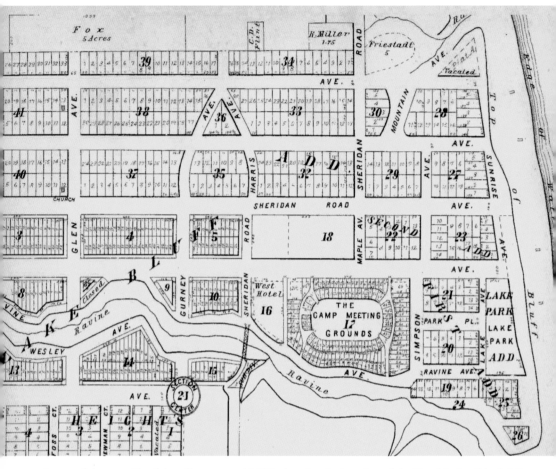

A map of the east side of the village around 1900, showing the location of the Hotel Irving (block 18) after it burned down and after the tabernacle (block 17) was dismantled.

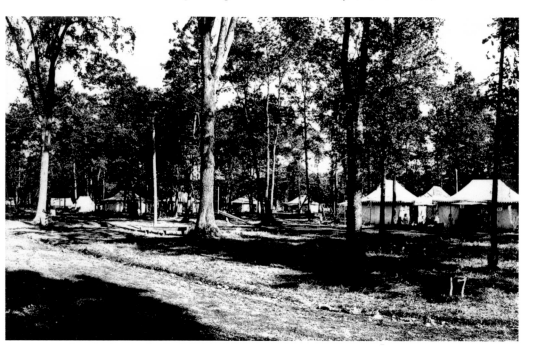

Arden Shore Summer Camp, *circa* 1910, was designed to provide a relaxing and restful haven for inner-city mothers and their children. The camp occupied approximately 50 acres on the northern edge of the village. By the 1930s, what was originally a summer camp had developed into a year-round home for neglected and troubled boys.

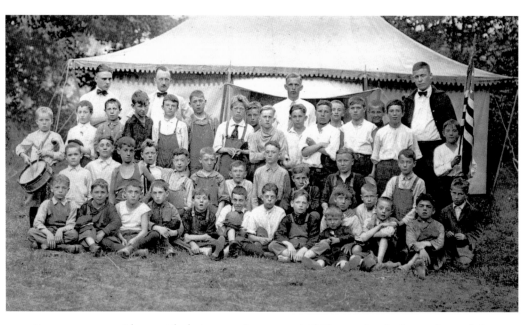

Summer camp residents with their counselors around 1920, standing in front of one of the tents on the grounds used for housing.

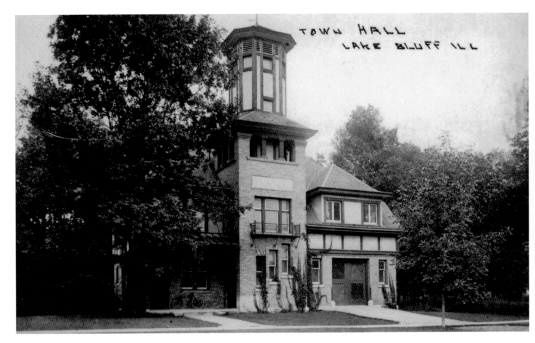

Built in 1905, Lake Bluff Village Hall replaced a small real estate office near the village green, which had acted as a temporary government office, following incorporation of the village in 1895. Money left over from the purchase of village land for what was to become the North Shore Electric Railroad funded the project and the village hired Webster Tomlinson, Frank Lloyd Wright's partner, as the architect.

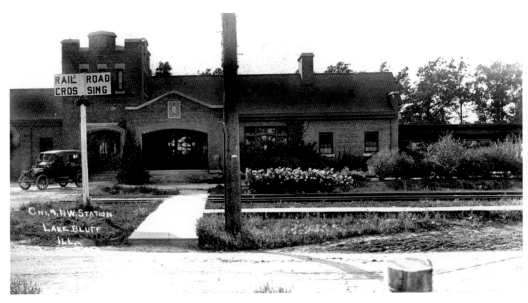

A new brick train station was erected in 1904, replacing an earlier wooden one. The architects were Granger and Frost, well-known for building stations along the North Shore.

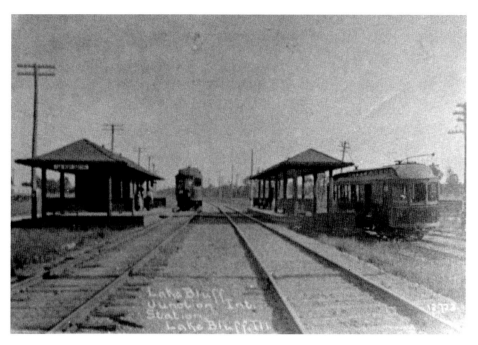

This photo shows the Lake Bluff North Shore Electric Line train station looking south in the early 1900s. The electric railroad provided service from Chicago to Milwaukee from 1902 until January 1963 when it closed due to bankruptcy. The present bike trail along Sheridan Road was along the North Shore Line's tracks.

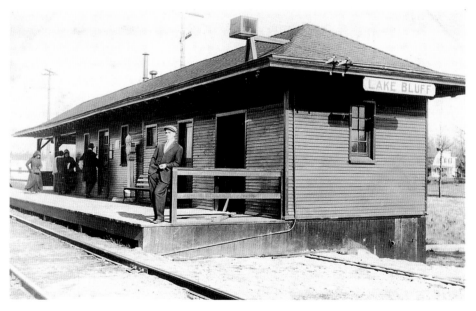

A close-up view of the North Shore Electric Railroad station taken in the early 1900s.

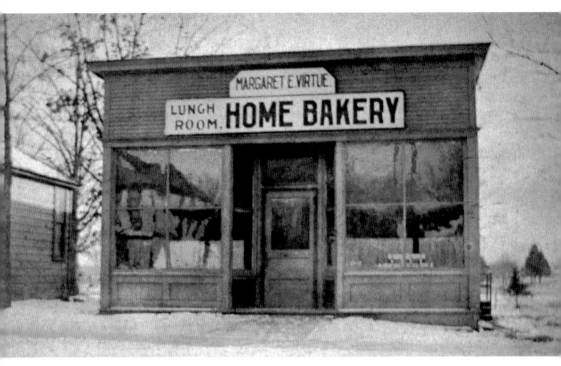

Myrtle Virtue's bakery, *circa* 1910. It was located across from Rosenthal and Helming's grocery store, now "Be Market." This simple wooden structure was very typical of the commercial buildings in the village at that time. Directly to the west of the bakery was a pool hall and ice cream parlor.

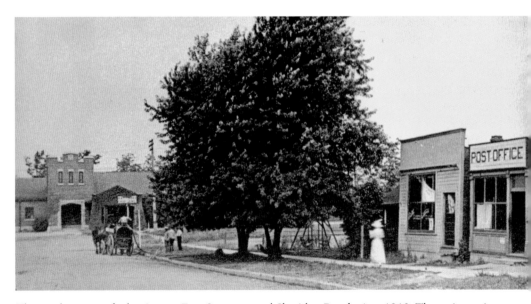

The north corner of what is now East Scranton and Sheridan Road, *circa* 1910. The train station built in 1904 is across the street. A village wagon is seen watering the road as Lake Bluff had no paved streets, and in the summer months, the rising dust could be unbearable

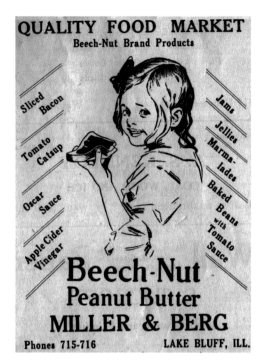

A 1915 ad from the *Lake Bluff Chat*, a weekly newspaper published by Lake Bluff Women's Club. Its editor, Isabella Ross, also served as Lake Bluff's postmistress. The ad advertised Miller and Berg grocery store, which stood on the north corner of the Merchant Block, next to the drug store.

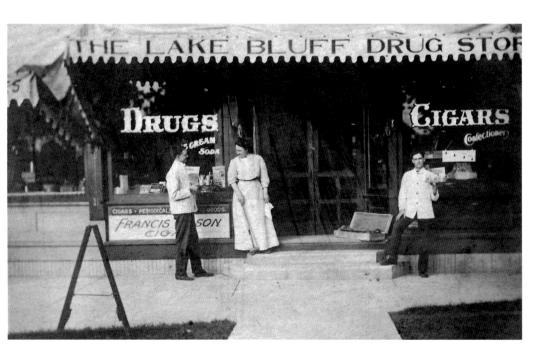

This early 1900s postcard shows the Lake Bluff Drug Store, located in what was called the "Merchant Block," named for Mr. Merchant. He owned the wooden structure that covered the entire block of what is now the corner of East Scranton and East Center Avenues, now the current home of "Inovasi" Restaurant.

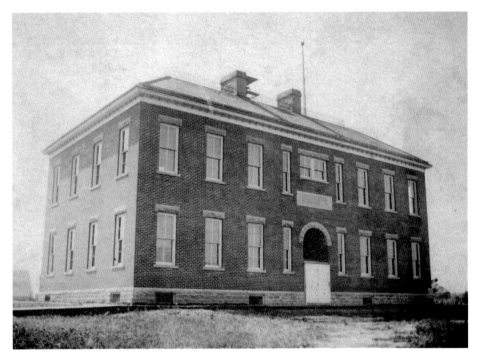

This photo was taken shortly after the brick Lake Bluff schoolhouse, known as East School, was erected in 1895, on the east side of town—a controversial move at the times as most school-age residents lived west of Green Bay Road. Modern for its time, the school boasted four classrooms, two grades to each room, and a total of four teachers.

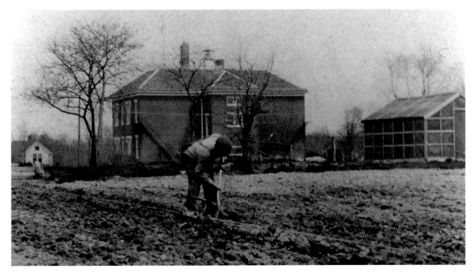

Taken in 1920, this photo shows a local farmer tilling his patch directly behind the 1895 East School. This emphasizes that although Lake Bluff was moving toward a modern suburban community, it still retained the vestiges of its agricultural farming roots.

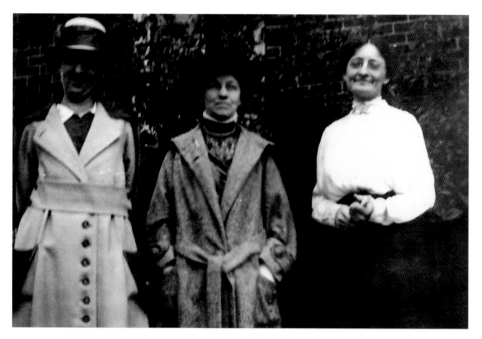

Three of the Lake Bluff School teachers standing in front of the school around 1917. At that time, the elementary school had four classrooms, two grades to each room. The teachers were paid an average of $50 per month and often boarded with local families.

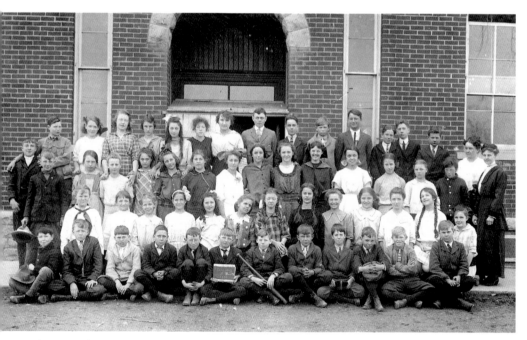

The seventh and eighth grade classes of the Lake Bluff School with their teacher, taken around 1917.

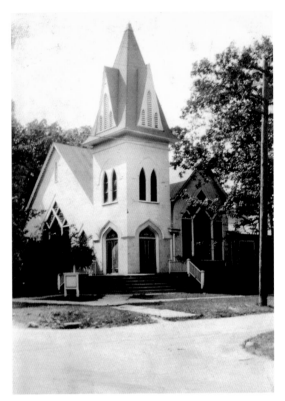

Grace Methodist Church around 1917, located on the northwest corner of Center Avenue and Glen. When the original Methodist Church was erected uptown near the corner of Center and Scranton in 1891, it was built on land that later became part of the village's right of way. In 1902, the new church replaced the previous one.

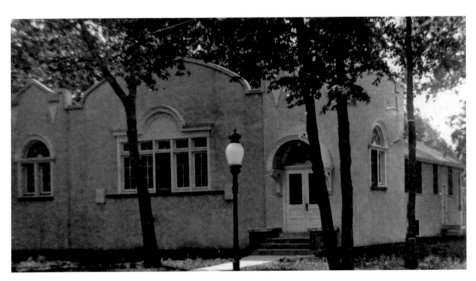

In 1920, the Union Church of Lake Bluff, which had its origins with the Rockland Union Church dating back to 1866, re-organized with a new charter. They moved an unused former YMCA dance hall from the Great Lakes Naval Station to a property the church owned on East Prospect Avenue.

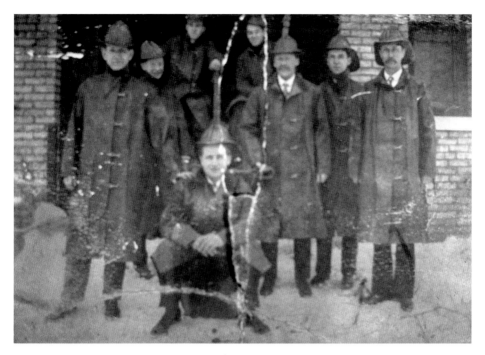

This 1909 newspaper photo shows the members of the volunteer fire department, known as the "Fire Laddies," in front of the fire station located in the Village Hall. The department's equipment was not motorized, and they could not afford horses at this time, so the firemen ran with the fire apparatus into the burning building.

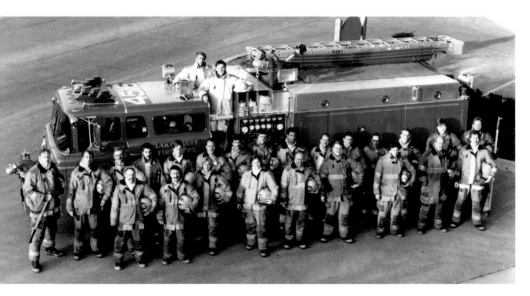

Today, the Lake Bluff Fire Department boasts over eighty members, and it is the only volunteer fire department on the North Shore. It continues the fine traditions and exemplary service to the community that it has given since 1897, when the fire department was founded after the burning of a five-story building, the Hotel Irving.

Proclamation

Whereas, A LARGE Number of the residents of LAKE BLUFF have expressed a wish to properly celebrate

July 4th, 1912

the One Hundred and Thirty-Sixth Anniversary of the Signing of the Declaration of Independence of THE UNITED STATES OF AMERICA

Therefore, as Village President, I hereby request that all Citizens join in the observance of the day by decorating their residences and grounds and by the appropriate display of THE AMERICAN FLAG.

Furthermore, I appoint Mr. Paul Mandeville to be The Director General of the Day and Evening, and respectfully ask the fullest co-operation of the Citizens with him to make the celebration an expression of 20th Century Patriotism, that will be to the highest credit of Our Community.

JOHN H. HOWARD
PRESIDENT

LAKE BLUFF, ILLINOIS,
JUNE 17, 1912

President John Howard made this proclamation in 1912, making the Fourth of July parade and festivities and office celebration in Lake Bluff. For many years, the American Legion Post 510 managed the events. More recently, a volunteer citizen group called the Lake Bluff Parade Committee has put on the parade, drawing upwards of 25,000 visitors each year.

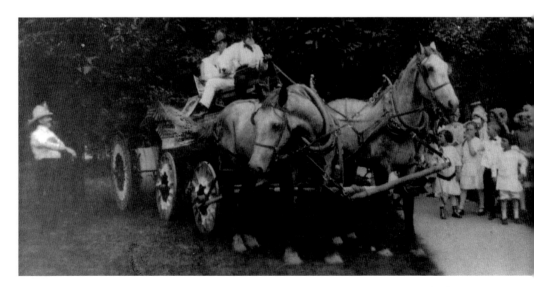

Members of the Lake Bluff Volunteer Fire Department driving the fire wagon in the first Fourth of July parade in 1911. The horses were borrowed for the occasion, as the department usually ran with the fire equipment to a fire. It was not until 1915 when the purchase of a motorized fire truck allowed for a quicker response to a fire.

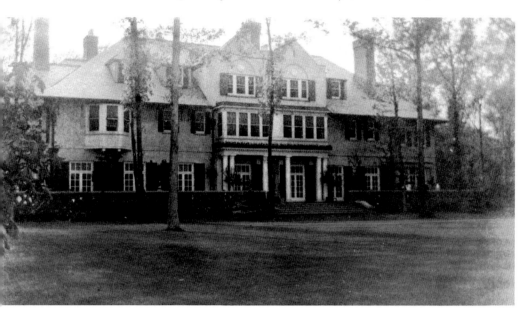

A lakeside view of the Field estate, "Lakeland." Situated on 31 acres including an extensive garden plan, Lakeland was designed by well-known landscape architect Warren Manning. Stanley Field lived in the house until his death in 1964. The manor house was razed in 1967 and the property was subdivided.

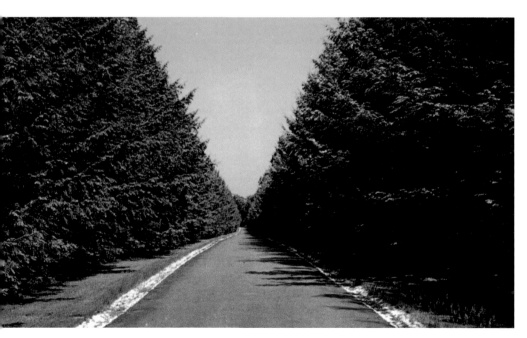

This postcard from the 1960s shows Lakeland Drive, which was the original driveway to the Field estate. The entry way was designed by landscape architect Warren Manning, with the hemlock trees lining the drive that remain today.

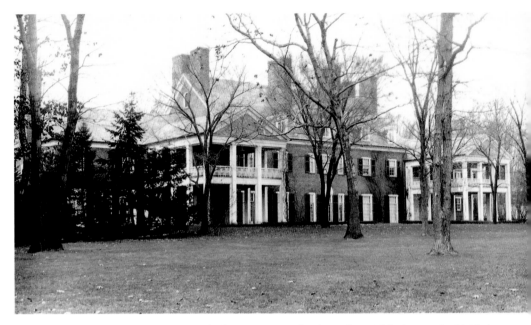

The estate of A. A. Sprague consisted of 31 acres south of Stanley Field's home. In 1911, he commissioned architect Harrie Lindeberg to design his home. In 1949, then-owner Ralph Isham commissioned architect Jerome Cerny to reduce the size of the house by removing the second floor. In 2009, the Cerny-designed home was razed, and a new home was constructed.

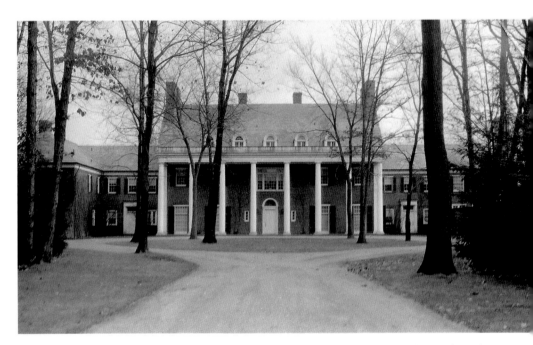

This is the front view of the A. A. Sprague home, showing the Harrie Lindeberg-designed Southern Colonial architecture of the original manor house.

Built in 1911, "Lansdowne" was the home of Harry and Bessie McNally Clow. It was designed by Benjamin Marshall, prominent Chicago architect, who also designed the Drake Hotel. Situated on 21 acres, it is the only Moffett Road estate still intact as it was when first built. In 2007, the Clow estate was sold, and most of the land was divided into seven lots.

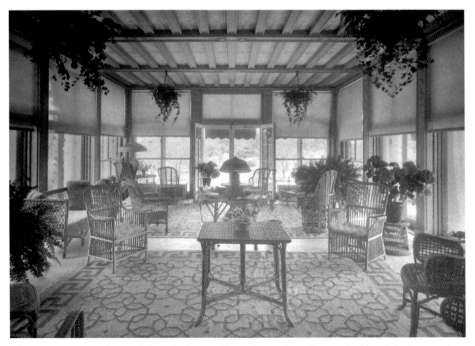

This is an interior photo of the solarium at "Lansdowne" on the south side of the home taken soon after the house was completed in 1911.

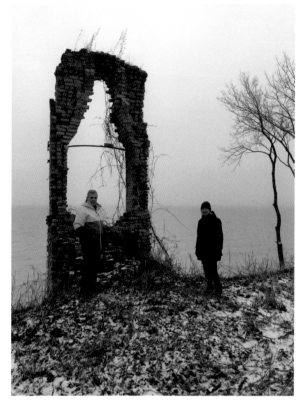

This chimney, perched on the edge of the bluff on property owned by Mary and Neil Dahlmann (pictured), is all that remains of the A. K. Stearns house built in the 1890s on 7 acres overlooking Lake Michigan. Originally, the house stood about 75 feet from the edge of the bluff, and erosion eventually caused the house to collapse, leaving just the chimney.

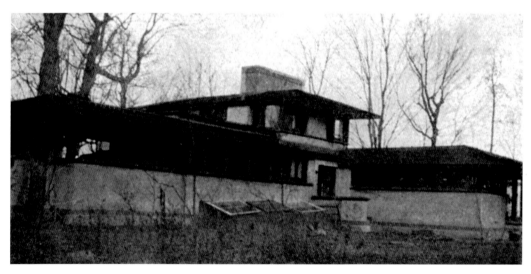

This is the only photo surviving of the home designed by Frank Lloyd Wright for Herbert and Mary Angster in 1911. The land for the home was purchased from A. K. Stearns, who had originally purchased 7 acres along the lake front from Ben Cloes. Situated on what is now Bluff Road, it was completely destroyed in a fire in 1956.

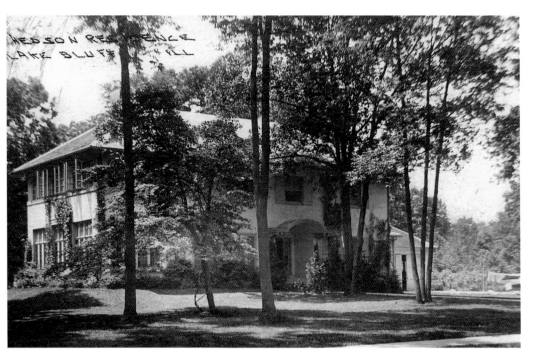

535 East Center Avenue was one of three houses built next to each other just before World War I. Known as the "Hyde Park" houses because they were owned by three neighbors from the Hyde Park area of Chicago who relocated to Lake Bluff, this was the beginning of the transition of the community from small town to suburban village.

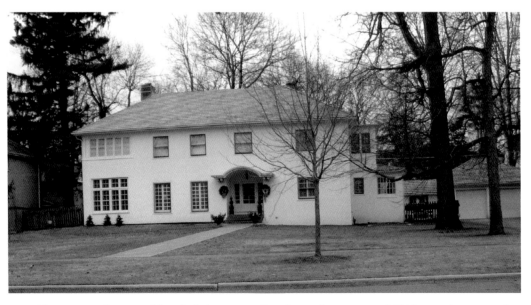

This is 535 today, one of three built in a row on East Center Avenue around 1913 as modern, up-to-date homes for suburban families, signaling the end of the summer cottage era of Lake Bluff.

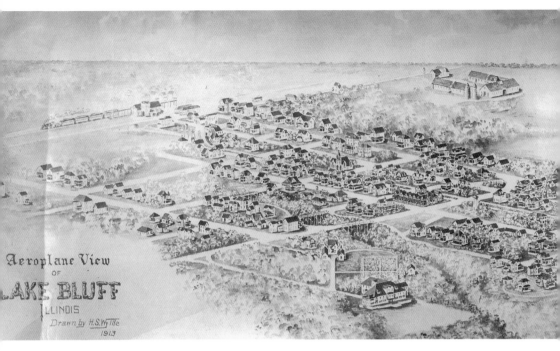

Aeroplane View OF LAKE BLUFF ILLINOIS Drawn by H.S.Wyllie 1913

This is a 1913 aerial sketch of Lake Bluff showing the boundaries from the lake front to what is now called Sheridan Road, then called Waukegan. It shows the Stanley Field estate on the bluff overlooking the lake and Crab Tree Farms in the upper right.

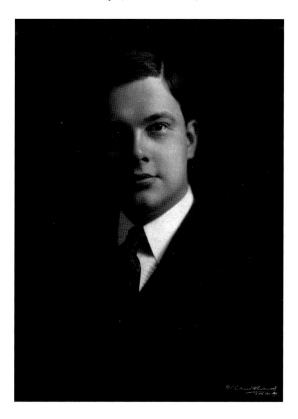

Right: Joyce Kilmer visited Lake Bluff at the invitation of Alice Corbin Henderson. It has been long thought that that Kilmer's famous poem "Trees" was inspired by the lush landscape and foliage of Lake Bluff in the summer.

Below: The center of the "Artist's Colony," Park Lane provided a bohemian influence in town during the years just prior to World War I. The home of William and Alice Corbin Henderson, the "Pink Palace," played host to numerous artists and literary figures of the day. William Henderson was a well-known artist and his wife, Alice, was the co-editor of *Poetry Magazine*.

LAKE BLUFF CLAIMS RECORD IN PATRIOTISM

Town of 700 Subscribes $40,000 to Loan and Sends 78 to War.

A new claimant, Lake Bluff, has advanced to receive honors as being the most patriotic town in the country among towns of its size. John Bemer Crosby, one of the leading citizens of this north shore suburb, is back of the claim, and announces that he challenges any and every other town in the country to make counterclaims.

Lake Bluff has a population of 700; its subscriptions to the third liberty loan exceeded $40,000; its Red Cross and war savings stamps records were at the top. The town has seventy-eight boys in service, not to mention John Kreutzberg, who received the croix de guerre for handling the Lake Bluff ambulance in France. The ambulance recently was annihilated when struck by a big shell.

At a great patriotic rally last night, which was attended by the entire village, Attorney Albert A. Kraft spoke. These meetings are another boast of Lake Bluff, coming regularly every two weeks and including on their program nationally prominent men.

Another speaker at the rally was Rev. John Robinson, a dignitary of the Established Church of Ireland, who gave an illuminating presentation of conditions in his native land. Dr. Robinson, who has three sons in the British army, all of them decorated, was a house guest of Mrs. Maurice Mandeville, who "loaned" him to the massmeeting.

A musical program by Mrs. Edna Wakefield and Mrs. Horace Wright Cook closed the evening, after an exhortation by Chairman Crosby for Lake Bluff to remember that it was over the top and its business for the remainder of the war was to retain that enviable position.

Left: This is the newspaper clipping from the *Chicago Tribune* describing Lake Bluff as the most patriotic town in the country. No other community ever seemed to challenge that claim.

Below: In 1917, the Lake Bluff community sent seventy-eight men to fight, over 10 percent of the population, and raised more money than any other community of our size. The *Chicago Tribune* proclaimed Lake Bluff as the most patriotic town in America. Money was also raised to equip and send an ambulance to the battlefield in France, including volunteer driver John Kreutzberg.

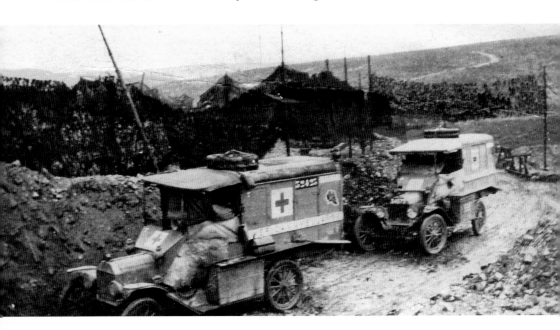

2

"A Chicken in Every Pot," "Brother, can You Spare a Dime?" and "Remember Pearl Harbor" (1920–1945)

The year 1920 ushered in not only a new decade, but also two sweeping changes to American life with the enactment of the Eighteenth and Nineteenth Amendments. Prohibition, women's suffrage, and the automobile age defined the 1920s. The automobile brought a sense of mobility and connection to the suburban landscape— reaching away from the city—and encouraging more and more families to venture out and form roots in the North Shore communities. Between 1920 and 1930, the population of Lake Bluff grew from 819 to 1,450—an impressive 77-percent increase.[1]

Members of the Rockland Union Church, who lost their place of worship to make way for the new electric railroad, held services at the Lake Bluff Country Club. In 1920, a growing membership formed the new Union Church of Lake Bluff, purchased a former hostess hall from the Great Lakes Naval Station, and relocated it to the site of the old Methodist tabernacle building. Along with Grace United Methodist Church, established in 1889 and rebuilt on its present site on East Center Avenue, the village now boasted two flourishing and well-attended churches. In 1921, returning war veterans founded the American Legion Post 510, which for many decades supported the annual Fourth of July parade and carnival, as well as Memorial and Veterans Day ceremonies.

The 1920s saw the development of two significant organizations that enhanced the vitality of the community. The beginning of a library system and the creation of the Lake Bluff Park District in 1925 added to the village's attractiveness and increased the number of amenities. Concerned about the lack of any long-range plans for the growth of Lake Bluff, the Women's Club petitioned the Village Board to create a planning commission to guide future development.

The newly formed Plan Commission hired civil engineer Jacob Crane to develop a plan and prepare up-to-date ordinances to regulate zoning, subdivisions, and buildings. Several subdivisions were laid out, but these were not built until after World War II. Unsightly billboards, which lined Green Bay and Sheridan Roads, were demolished. The uptown business area, which was a rather ramshackle cluster of small buildings on an unpaved street, was expanded and improved over time. First came a brick building

on the south side of Scranton Avenue, with three storefronts and an apartment over the westernmost space. The post office moved into the center section, with a tea shop next to it. After a fire in 1923, the building was reconstructed, this time with three second-story apartments. A few years later, two similarly styled brick buildings were erected with stores and apartments. A pharmacy operated in the larger building on the corner of Scranton and Center Avenues, and one of the storefronts housed the Lake Bluff Public Library.

In 1922, a large addition was made to the 1895 four-room school on the corner of Sheridan Place and Vincent Court. Six classrooms and a gymnasium now supported the growing school population. The new gym, with a stage and built-in fireplace, soon became Lake Bluff's community room, with public dances held on weekends and Friday-night silent movies shown from the projection room above the basketball net.

The ill winds of Prohibition swirled around the North Shore, Lake Bluff included. At least one prominent family, with alleged ties to the Capone Mob, was embroiled in scandal, and several local robberies were tied to some homegrown criminal elements. In late October 1928, Lake Bluff was rocked by the sensational discovery of a nude woman, near death and badly burned, in the basement of the Village Hall. The notoriety and publicity that followed this local mystery have lasted to the present day.

The stock market collapse in 1929, and the ensuing Great Depression, found the village in serious financial difficulty. However, by 1935, with careful management and expense reductions, there was no public debt, and the community rejected yet another proposal to be annexed to Lake Forest. New home construction began to flourish by the late 1930s, and a new public high school for students from the Lake Bluff–Lake Forest area was constructed using WPA (Works Project Administration) dollars in 1935. The population, in twenty years, increased by 100 percent, and it would take another war to put a temporary stop to Lake Bluff's growth as a North Shore suburb.[2]

The United States' entry into World War II rekindled the patriotic spirit that existed in Lake Bluff during World War I. Besides the young men and women who served in the armed forces, the folks at home also did their part. Red Cross drives, Liberty Bond rallies, victory gardens, and scrap metal collecting, along with food, gas, and goods rationing became a daily part of life. Lake Bluff's proximity to both the Great Lakes Naval Station and Fort Sheridan certainly had an impact. Due to scarce housing for families of service personnel, many residents rented out rooms, reopened closed summer cottages, and found other ways to help ease the burden for relocated wartime families. There were many blue stars hanging in Lake Bluff windows, signifying active armed forces members in that household. By the end of World War II, there were several gold stars displayed in windows to honor family members who had died.

The year 1945 brought not only the end of the war, but returning soldiers and sailors, eager to start families and move on. Veterans were welcomed to Lake Bluff with enthusiasm and pride. The country was poised to begin the greatest era of national growth and prosperity it had ever experienced.

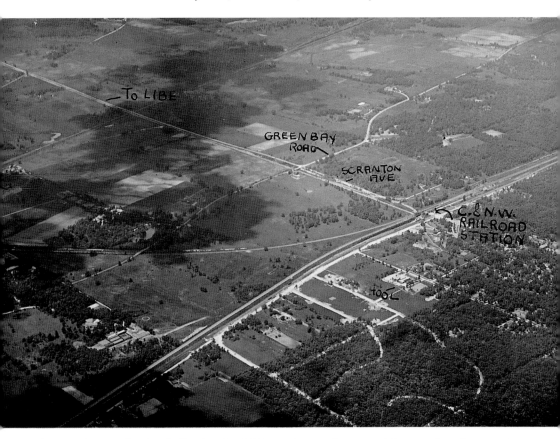

This aerial view of Lake Bluff, taken in 1923, was just at the cusp of the promise of economic growth and prosperity of the 1920s, and Lake Bluff was eager to be a part of the boom. As you can see, most of the area was still farmland or undeveloped property.

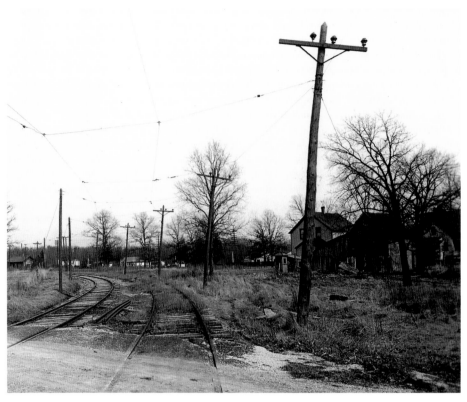

Looking north along train tracks across Route 176 (Rockland Road) with Mawman Avenue on the left, *circa* 1925.

Intersection of Rockland Road (176) and Waukegan Road in 1925. This junction had for years been called "Creamery Corners" for a small dairy farm located near there.

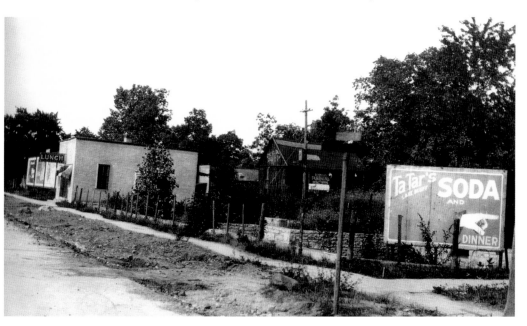

This photo was taken from the train station looking at the northwest corner of Sheridan Road and east Scranton Avenue. It shows a small one story "greasy spoon" diner and the large barn to the rear. The billboard sign points to Mrs. Tatar's lunchroom further down the street on Scranton Avenue.

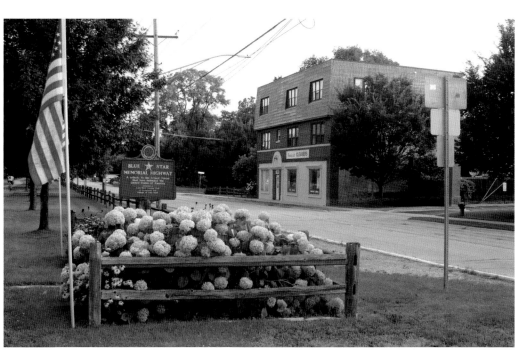

A recent photo looking north from the train station showing the former 1920s one-story diner, though as it is today, with two additional stories added.

47

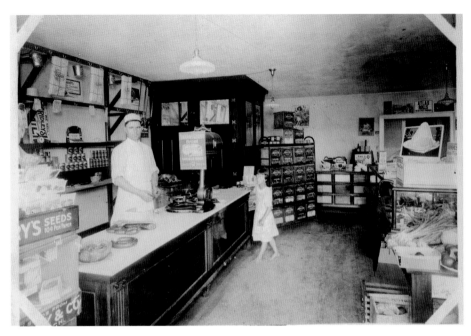

The interior of a grocery store taken in the late 1920s. The shop was located in the Griffith Building, built in 1925; it is now on the National Register of Historic Properties. It was designed by well-known architect Stanley Anderson. The location is currently occupied by Bluffington's Café.

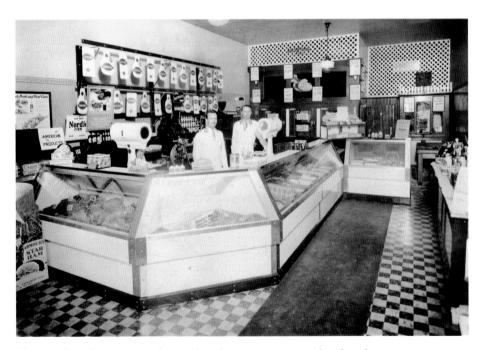

The same location, ten years later, when the store was now a butcher shop.

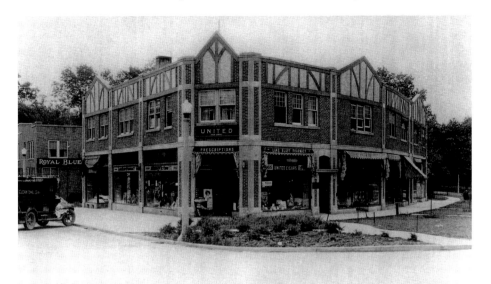

The Sankiewicz block in 1928, named for the developer. This photo shows the building shortly after it was completed, replacing the Merchant's Block, which had burned down in 1917.

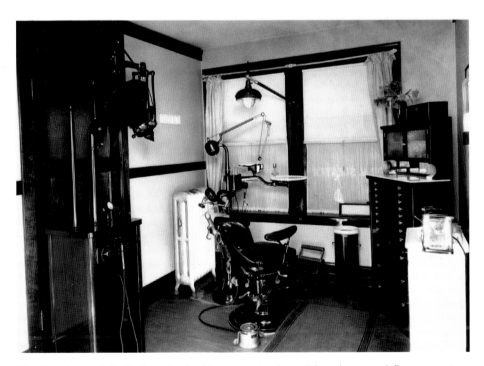

The first floor of the Sankiewicz building contained retail but the second floor was given over to offices and apartments. This is the interior examination room of local dentist, Dr. Victor Sleeter, taken in the mid-1930s, located on the second floor. Later, Sleeter would serve as village president from 1947–49.

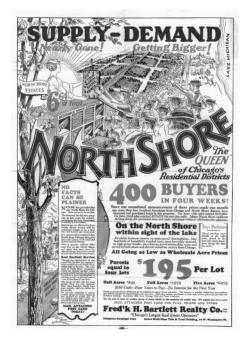

Left: In the 1920s, the development of the "North Shore Estates," the area now known as the "North Terrace," stretched from Mawman to the border of Tangley Oaks. The developer attempted to capture the enthusiastic young owner; however, the stock market crash of 1929 ended those dreams, and this area would not see new homes built until after World War II.

Below: A 1920s map of a new proposed subdivision for Lake Bluff, which hoped to capture interest in the suburban real estate boom along Chicago's north shore.

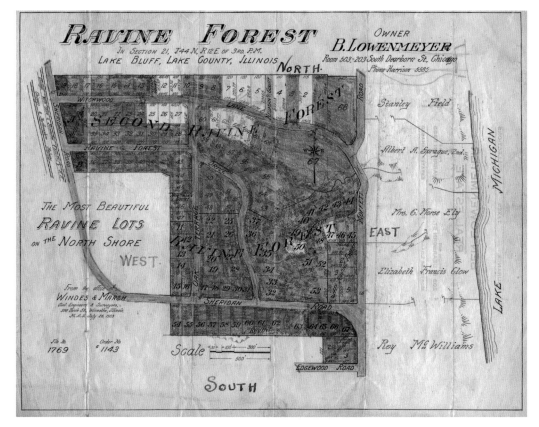

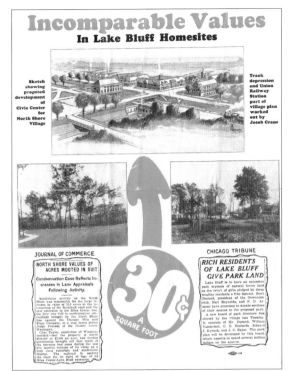

This is an ad dating to the mid-1920s promoting Lake Bluff as a north shore progressive suburb with ample parkland and a forward-looking community. It capitalizes on the 1924 Crane Urban Study report commissioned by the village to provide a blueprint of revitalization of the community.

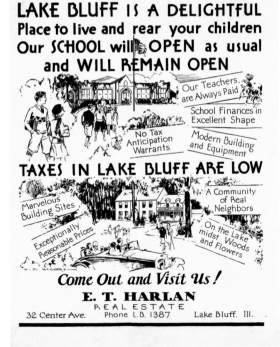

The depression was still going on and many schools in the nation were closing due to lack of funding, so this real estate ad from 1937 assured prospective home buyers that the Lake Bluff school system was financially secure. E. T. Harlan was a prominent local builder in the 1930s through the 1960s, both in Lake Bluff and Lake Forest.

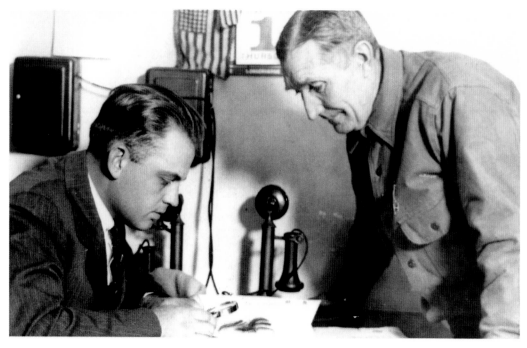

Photo of Lake Bluff Police Chief Barney Rosenhagen on the right and Officer Eugene Spaid on the left examining evidence from the Elfredia Knnak case in 1928. Finding a nude woman, badly burned, in the basement of the Village Hall not only rocked the community but also caused a national sensation across the nation.

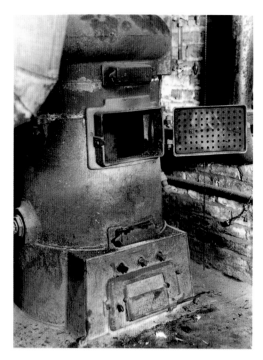

The furnace located in the basement of the Village Hall where on the morning of October 30, 1928, former school teacher Elfredia Knnak was found, barely alive. She would die three days later, leaving a mystery behind that still puzzles people.

This view, looking towards the east on Center Avenue past the Village Hall in 1928, shows the police department's lone vehicle—a motorcycle—parked on the road. The motorcycle was a recent purchase, with bicycles being the preferred mode of transportation prior to its purchase.

THE WEIRD CASE OF ELFRIEDA KNAAK

Another Thriller in Mystery Series

BY ALFRED PROWITT.

Chris Louis, janitor of the village hall at Lake Bluff, entered the police station in the building at 7 o'clock on the morning of Oct. 30, 1928. Chief Barney Rosenhager, who had arrived just a minute earlier, said "Better go down and fire the furnace."

Louis nodded. It was a chilly day. The office was so uncomfortable that he commented, "Fire must have gone out."

Chief Rosenhager related that he had dropped in at the station at 9:30 the night before and had banked the furnace fire. "Maybe I didn't do a good job of it," he admitted.

The two men agreed that Night Policeman Charles Hitchcock's recent leg fracture had upset routine. Hitchcock used to drop in at the station at night and tend the fire. But he had been confined to his home, for several days, an accident casualty.

Mumbling, Louis started down to the basement. At the head of the stairs he tried the switch,

HORROR IN THE FURNACE ROOM—Chris Louis, Lake Bluff Village Hall janitor, stands trans-

on one foot, held the other in the fire and when it was burned so that the bone began to crumble withdrew it, then stood on the burned foot and held the other in the furnace and finally, standing on both charred feet, held her head and her arms in the furnace until they were charred too? The idea is insane!"

Lake County employed the Hargraves Detective Agency to take over the investigation. A $1,000 reward was offered for information that Miss Knaak had been slain or had a companion beside the furnace.

In the midst of it all, Ezra MacVeagh, alias James Kelly, arrested at San Antonio, Tex., as an Army deserter, confessed that he had murdered Miss Knaak. While being brought here for questioning he made seven suicide attempts. But records showed that he had been a patient in an insane asylum at Elgin on the night of Miss Knaak's fatal burns.

Charles Francis Coe, criminologist, once offered this theory about the mystery.

"She did not know of Hitchcock's injury. She phoned twice to Lake Bluff. Someone answered her. Perhaps he told her Hitch-

A *Chicago Daily News* article from 1944 reviewing the Village Hall furnace mystery involving the death of Elfredia Knnak and the involvement of Charles Hitchcock, night policeman of Lake Bluff.

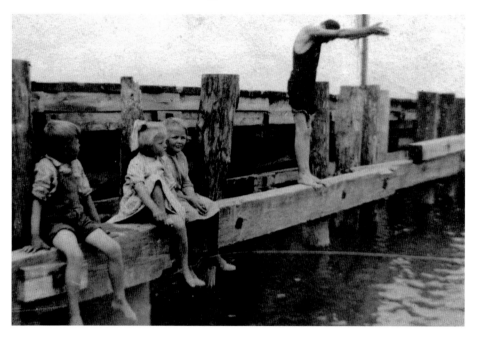

The original wooden pier dating from the summer resort days. This photo, *circa* 1920s, shows some young residents of the Lake Bluff Children's home enjoying an outing at the beach.

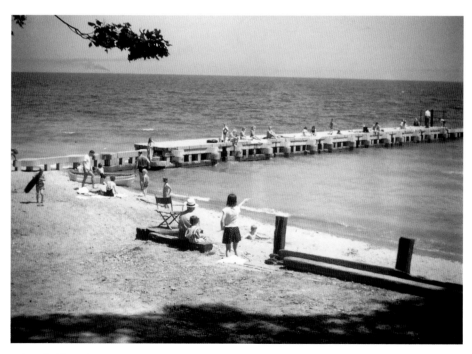

Lake Bluff beach, *circa* 1940s. The concrete pier was built in 1939, replacing an old wooden pier from camp meeting days.

Photo showing the 1922 addition to the Lake Bluff school, which added a gymnasium/community room and six classrooms, three on each side of the gym. This was considered modern and forward-thinking at the time, although later generations of teachers and students would wonder why.

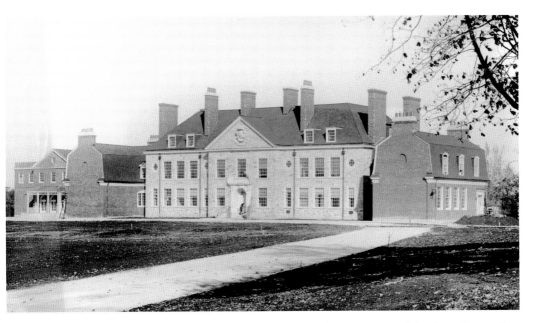

Lake Forest High School, built in 1935 as part of a federal WPA project of the Great Depression, was designed to resemble a lakefront mansion so it would blend into the local landscape. Enrollment the first year was a little over 400 students.

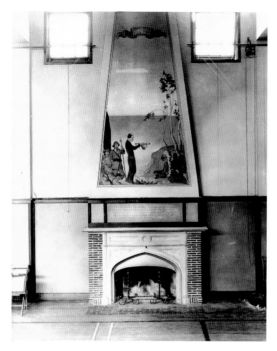

In 1926, local artist Marguarite Kruetzberg painted a mural to hang above the fireplace located in the new gymnasium at East School. The mural depicted the explorers Father Marquette and Louis Joliet landing at Lake Bluff in 1688. The mural would remain until East School was razed in 2011. In 2015, it was professionally restored and rehung in the Village Hall boardroom.

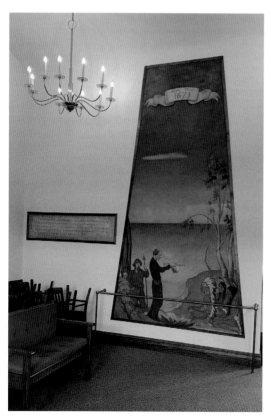

Glass slides found in the movie projection room above the 1922 gymnasium addition to the Lake Bluff School were ads for the weekly silent movies held there in the mid-1920s for the community. This was the first "movie theater" in both Lake Bluff and Lake Forest. The gym was designed to be a community center for the village and, up to World War II, held numerous activities including dance and lectures as well as movies for the residents' benefit.

A publicity photo of Marian Claire from the 1920s when she was touring Europe as an operatic signer of some renown.

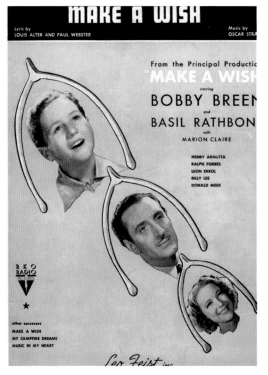

Sheet music from the 1937 movie *Make a Wish* staring Basil Rathbone, Bobby Breen, and Marian Claire Cook. Cook lived at 700 East Center Avenue and was considered by local residents to be a child prodigy. Living at home in Lake Bluff, Marian Claire became a radio star, hosting *The Chicago Theater of the Air* in the 1940s.

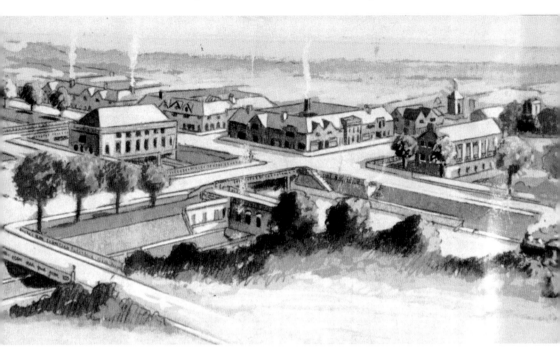

A sketch of a proposed new configuration of the uptown area of Sheridan and Scranton Avenues. This was part of a 1924 redevelopment plan adopted by the Lake Bluff Plan Commission. The plan was for new civic buildings and train tracks below street level. The stock market crash and the Great Depression that followed put an end to those ideas.

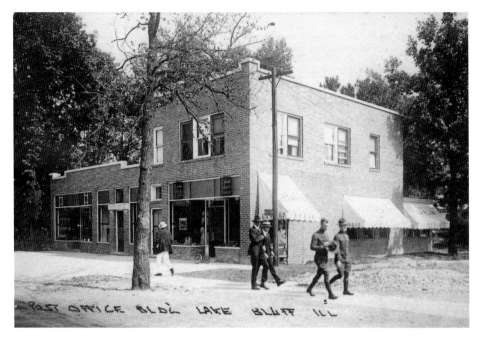

This postcard from 1922 shows the newly built brick commercial building on the south side of Scranton Avenue. It housed Mrs. Tatar's Tea Room and the Lake Bluff Post Office, which moved from a rather dilapidated wood building further west on Scranton Avenue.

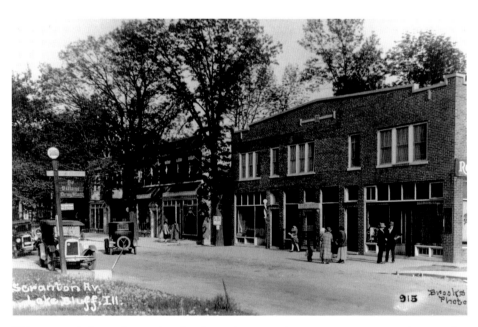

This postcard shows the south side of East Scranton Avenue sometime around 1925 after a fire had destroyed part of the building on the right, which housed the post office. It was rebuilt with the second story extended fully across the length of the building.

Looking north from the corner of Glen and Scranton showing the Lake Bluff Children's Home block. This photo was taken *circa* 1930 and shows the integration of the original wooden structures with the new fireproof brick administration building. By the 1940s, all the old buildings would be replaced with the brick Georgian-style edifices.

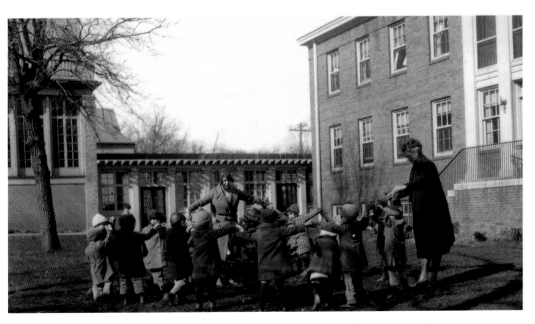

Residents of the orphanage playing "Ring Around the Rosie" with two of the house parents. Recreational activities were a large part of the daily routine for all the youngsters who ranged from infants to eighth grade.

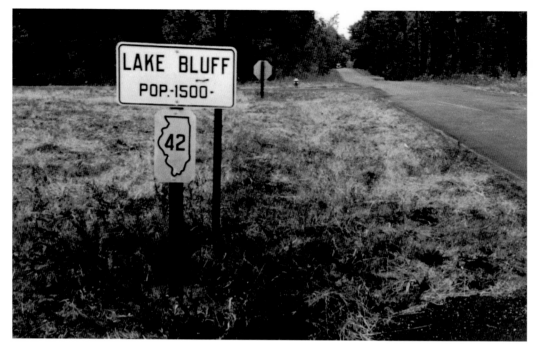

Taken *circa* 1935, the photo shows the village limits at Sheridan Road and Moffett Road. At the time, Sheridan Road was more popularly known as Illinois Route 42.

This 1938 photo shows the south side of East Scranton Avenue, which, at the time, housed a grocery store and meat market along with residential apartments on the second floor.

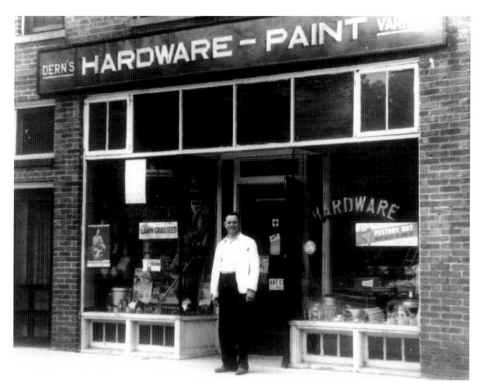

This 1942 photo shows the Lake Bluff Hardware and Mr. Dern, the proprietor, standing proudly in front of his newly opened business. The hardware store will last until the late 1980s when the retail businesses in the village started to decline.

A photo of the corner of Center and Scranton taken *circa* 1940 showing the Lake Bluff Drug Store and soda fountain on the corner.

by Montreal citizens to obtain pilots to fly bombers across the Atlantic. This was before the RAF Ferry command, and later Transport command came into existence.

By 1942 he was flying Liberators and the B-17 Fortresses across the Atlantic, then came the Mitchell bombers, the Bostons and finally the Lancasters. He flew the Atlantic 100 times delivering aircraft to Europe, and made flights to many other parts of the world, particularly to the Pacific area.

Flies Many Famous Men

Captain Vanderkloot took a converted American B-24, with a crew of five, to Britain and picked up Mr. Churchill in London. Next he flew to Gibraltar, to Cairo, to Teheran in Persia, and finally reached Moscow. Among the passengers, in addition to Mr. Churchill, were Averell Harriman, the personal representative of the late President Roosevelt at the Moscow conference, and Air Marshal Sir Charles Portal, chief of staff, Royal Air Force.

This was the beginning of the career of the "Commando," which probably carried more distinguished passengers during the war than any other aircraft. The machine eventually came to a tragic end, but Captain Vanderkloot was not the pilot of the Commando at that time.

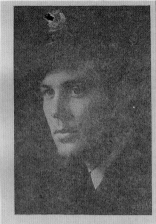

CAPT. VANDERKLOOT

Anthony Eden, Britain's former Foreign secretary, was flown across the Atlantic to a Washington conference.

Tribute From the King

Among Captain Vanderkloot's possessions are framed signed photographs of Winston Churchill and Field Marshal Smuts, and the framed citation that created him in 1942 an hon-

William Vanderkloot, Jr., was raised in Lake Bluff at 345 East Prospect Avenue. Vanderkloot loved flying, and as a young pilot, in early 1941, before the U.S. entered World War II, he went to Canada and joined the Royal Air Force Ferry Command. He later became Winston Churchill's pilot, flying him on secret missions, including the famous meeting with Roosevelt and Stalin in Casablanca in 1943.

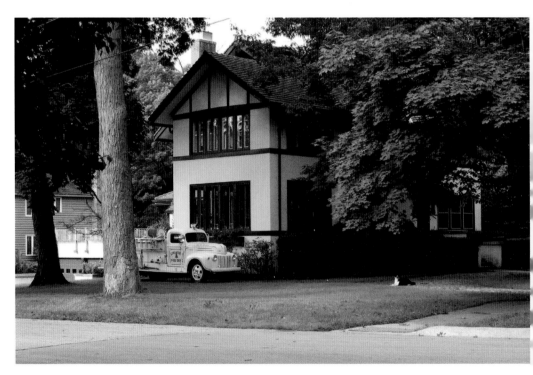

This is a recent photo of 345 East Prospect Avenue, the boyhood home of William Vanderkloot, Jr., Churchill's pilot in World War I. This prairie-style, three-story home was built in 1911 by Vanderkloot's father to replace an older Queen Anne-style home destroyed by fire.

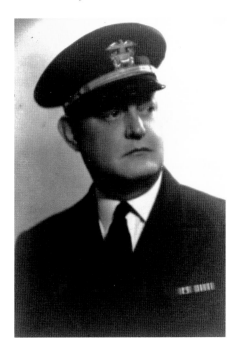

David Smithson served as village president from 1933–1935, and even though he was considered "overage," he volunteered for active duty as a lieutenant commander in the U.S. Navy during World War II. Just before returning home from a tour of duty in the Pacific in the spring of 1945, Smithson died aboard ship, leaving his wife and daughter, along with the entire village, to mourn his death.

This 1942 letter send to the American Legion Post 510 thanking the Legionnaires for one of the gift packages they sent to the Lake Bluff men and women serving overseas. These gift packages continued to be sent throughout the war years.

✚

AMERICAN RED CROSS

SERVICE CLUB

NORTHERN IRELAND

15th June, 1942.

The American Legion,
Lake Bluff Post No. 510,
Lake Bluff,
Illinois. U.S.A.

Dear Friends,

I received your very fine gift and letter to-day and am appreciative for it. One does not realise how important it is to carry a cigarette lighter here, until he realises that matches are a thing which can hardly be bought since this war has been going on. Your gift came at the most opportune moment, as it was only yesterday my own cigarette lighter had refused to work any more.

I am working as Club Director in the Belfast Service Club of the American Red Cross here in Northern Ireland. We are attempting to make a Home for the boys in the Army away from home, and are setting up in addition to Recreation facilities and programs, Dormitory facilities, Canteens, Library rooms, Information Bureau, Home hospitality priviliges, and last but not least a place where a bit of the American customs are carried out, to make the boys feel not quite so far away from our own home country.

I wish to express my kindest regards to all my friends of the Lake Bluff American Legion Post, and wish them best of success in the very fine work which you are carrying out. Tell Arch Bowen & Harold Sweeney to keep the Junior Base-ball teams very much in the seasons standings this year.

Sincerely yours,

(CLUB DIRECTOR)

3

POST-WAR BABY BOOM TO
MAN ON THE MOON (1945–1970)

Bill Harlan came home from the South Pacific after serving as a fighter pilot in the famous Black Sheep Squadron to join his dad, Earl "Red" Harlan, a local building contractor. Earl had begun constructing homes in the village in the late 1930s, but due to the short supply of building materials during the war years, he was forced to end construction until after World War II. Together, the father-son partnership built over fifty homes in Lake Bluff, including the "Idle Hour" subdivision along Sunset Place and tidy ranch homes along East Blodgett Avenue.

Young families were attracted to the many amenities that the village had to offer in those post-war years, leading to an influx of new residents. The terrace subdivisions, which had been platted out during the 1920s real estate boom only to falter with the stock market crash, were developed, beginning with the North Terrace. Soon, homes with two and three bedrooms lined streets with names like Lincoln and Washington. In the late 1950s, the Chicago Construction Company offered one-story houses in the East Terrace, followed in 1961 by larger two-story homes in the West Terrace. There were several models to choose from, and prices started in the low $20,000s.

In April 1951, during the Korean War, President Harry Truman fired General Douglas MacArthur for insubordination. This was a highly controversial move as many thought MacArthur was planning to run for president in 1952. MacArthur made a farewell speech to Congress and then planned to return to his boyhood home in Milwaukee by way of motorcade from Chicago, traveling north on Sheridan Road. Although MacArthur was not planning any stops along the way, members of the Lake Buff Women's Club had other ideas.

The police chief, whose wife was the club's president, was persuaded to block Sheridan Road and divert the motorcade to the Lake Bluff War Memorial so the general could pay his respects to the village's service members and lay a wreath. MacArthur and his staff had no idea of this unplanned stop, but the entire village did. Lake Bluff schools were dismissed so students could attend the impromptu ceremony, and villagers headed to the uptown area to see the event. Photos were taken, hands were shaken, and soon

the cavalcade was allowed to continue on its way. This incident became a part of local lore, known as "the day Lake Bluff kidnapped MacArthur."

Soon after the war, a single-story addition was built onto the elementary school. A second was added in 1950. In 1955, a seventh- and eighth-grade junior high was constructed next door, with two more elementary schools erected in 1963 and 1967. The school located in Knollwood was known as West School, and the Green Bay Road school was called Central. The baby boom was impacting Lake Bluff.

The population of the village in 1950 was 2,000, and by 1970, it had reached almost 5,000 residents.[1] The community's social and service clubs saw a significant increase in membership and influence during this period. Veterans of World War II joined those from World War I in making Lake Bluff's American Legion Post a prominent service organization with its continuing sponsorship of the annual Fourth of July parade and carnival, the coordination of village ceremonies for Veterans and Memorial Days, and its participation in other local events.

The North Shore Electric Railroad—whose tracks were laid through Lake Bluff at the beginning of the twentieth century, and was the main transportation means for many villagers—finally ran its last train in January 1963, signaling the end of an era. The 1950s and '60s also saw the dismantling of several of the great local estates. The large house and acreage of Tangley Oaks, originally owned by the Armour family, was sold to United Educators. The Field Mansion, overlooking Lake Michigan, was demolished in 1967 after the death of Stanley Field. Stonebridge, on Green Bay Road, had already been transformed into a monastery and retreat for the Servite Fathers in the 1940s.

During the 1960s, Lake Bluff was home to a number of prominent advertising executives who helped set the national cultural landscape of the period. Among them was Draper Daniels, the creative head of Leo Burnett Company, and C. Marvin Potts, the head of the art department of Foote, Cone and Belding Agency, who created the iconic pitcher of Kool-Aid ad and later the Kool Aid Man image. Daniels, often said to be the model for the infamous character Don Draper on *Mad Men*, which ran from 2007–2015, was the creator behind the ads for the Marlboro Man, the Maytag Repair Man, Charlie the Tuna, and Elsie the Borden Cow.

The uptown area itself was also evolving. In 1959, a new post office was erected on the northeast corner of Walnut and Scranton Avenues, along with adjacent offices with apartments above. The same year, Graham Munch, who operated a pharmacy out of his home down the street from the new post office, retired and gave the first floor to the library for its new home. Previously, the library had operated out of a storefront across the street. Howie Willms, a long-time resident and clerk of Mr. Munch, built a new brick pharmacy right next door. Along with the new single-story apartments and offices built by the Harlans on the corner of Oak and Scranton Avenues, the north side of the uptown area now complemented the brick 1920s building on the south side.

Blair Park, located on land that had originally been platted for development during the real estate boom of the 1920s, was laid out for recreational purposes in 1967. The eighteen-hole Lake Bluff golf course followed a year later. The golf course project was spearheaded by a group of civic-minded residents who felt the course would be an asset for residents, as well as an attractive feature for the local real estate market.

The end of World War II and landing a man on the moon bookended a period of growth and prosperity in Lake Bluff that was reflective of the entire nation.

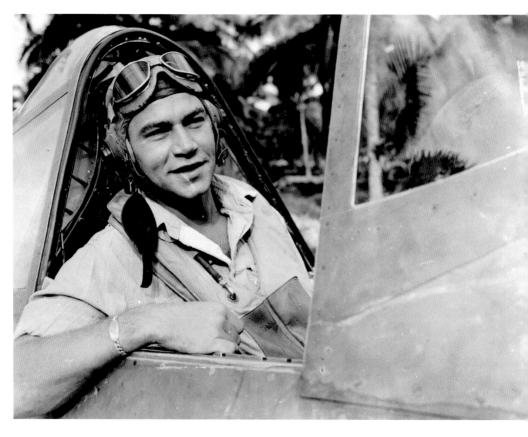

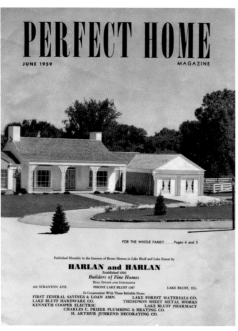

Above: Marine pilot William "Bill" Harlan of Lake Bluff, who was a member of the famous Black Sheep Squadron in World War II, joined with his builder father Earl "Red" Harlan to form Harlan and Harlan Home Builders in 1947. Their firm was responsible for building numerous homes for young families in post war Lake Bluff and Lake Forest.

Left: The June 1959 magazine *Perfect Home* advertised local home builders Harlan and Harlan. Promotional magazines such as this were popular in the 1950s and designed to attract young families to new, affordable homes in the suburbs.

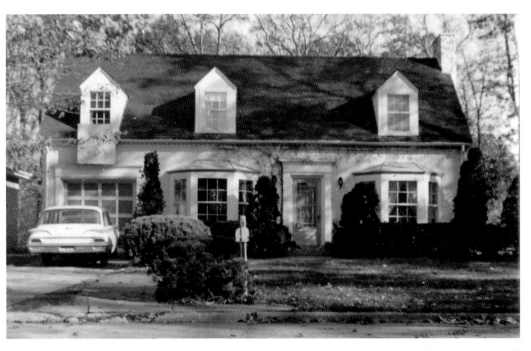

Photo of 309 Briar Lane, a Harlan home, around 1960. Notice the basketball net and the 1960 Ford family station wagon in the driveway—a perfect suburban setting.

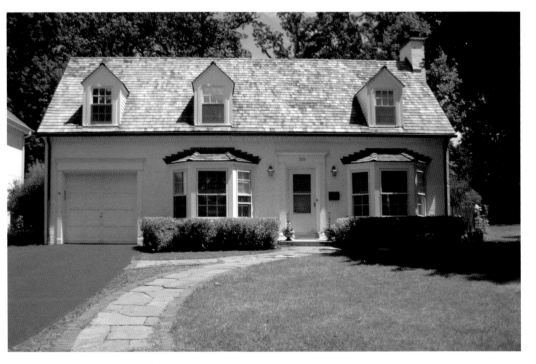

No. 309 Briar Lane today.

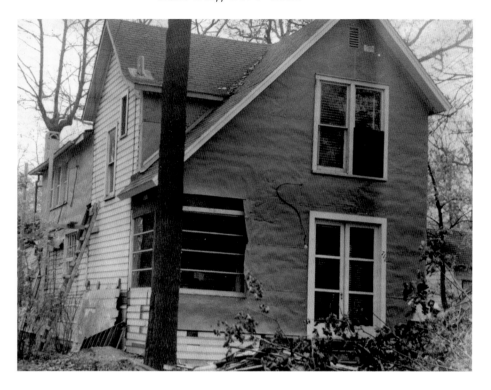

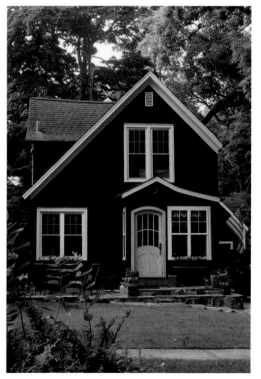

Above: This black-and-white photo from a *Better Homes and Gardens* magazine article, March 1947, shows the step-by-step renovation of 711 East Prospect Avenue from an 1890s cottage into a modern house of the day, suitable for a young suburban family.

Left: No. 711 East Prospect Avenue as it looks today. Originally a *circa* 1890 camp meeting cottage, it underwent a major renovation in 1947.

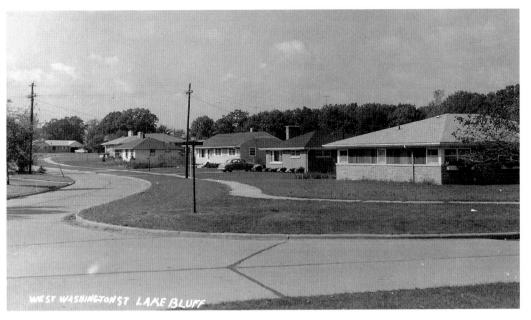

The intersection of Lincoln and West Washington *circa* 1950. The northeast quadrant of Route 176 and Green Bay Road, known as the North Terrace, was developed immediately after the end of World War II. Returning G.I.s, eager to live their version of the American Dream, flocked with their families to these affordable ranch homes that sprang up across the country.

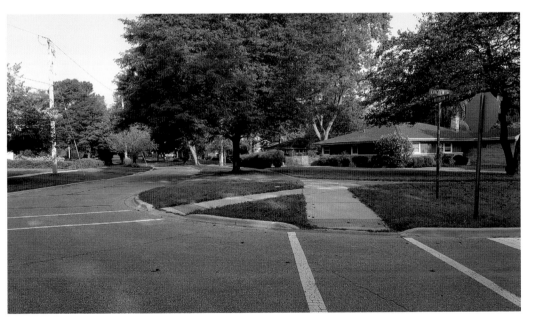

A current photo of the intersection of West Washington and Lincoln Avenues taken approximately seventy years after the first photograph. Many of these one-story ranch homes have been updated through the years and added on to meet the needs of modern family living.

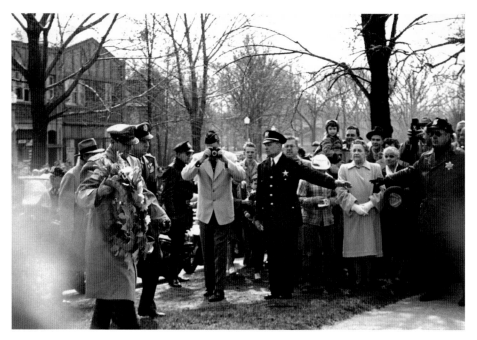

Photo shows General Douglas MacArthur laying a wreath at the Lake Bluff War Memorial in April 1951. The Lake Bluff police officer holding back the crowd was Sgt. Gunner Swalgren, long-time member of the police department.

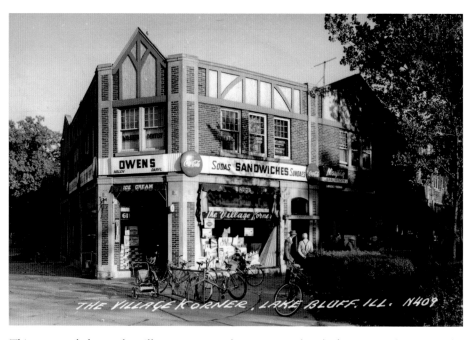

This postcard shows the village's Korners drug store and soda fountain, adjacent to the Maytag store around the time of MacArthur's "visit."

From National Crisis to Centennial Celebration (1970–1995)

The 1970s arrived with a roar. Anger over the Vietnam War and other national issues spilled over to Lake Forest High School in 1971 when a group of students took over the main office and the front lawn. Led by a couple of Lake Bluffers, the protest was short-lived but represented the continuation of a call for change that had its roots in the turbulent 1960s.

In 1969, school enrollment in the Lake Bluff schools was at 1,289, but by 1981, there were only 683 students.[1] This decline in enrollment forced the school district to divide the schools by grade level and close East School because of the costly repairs needed to maintain it. The last surge of the baby boom generation brought an expectation of future student growth for the high school, and West Campus was built in 1971 to educate freshmen and sophomores. An upswing in school enrollment in the early 1980s led to the reopening of East School as a K–2nd Grade.

The Lake Bluff Children's Home, which had housed and comforted thousands of children through seven decades, closed its doors as a permanent institution in 1970. The new model was foster care, and large orphanages were out of favor. An alternative school for girls was housed there for a short time, but by the mid-'70s, the entire campus of seven brick Georgian-style buildings, which occupied an entire block near the uptown, was for sale. When no viable buyers appeared, the campus was sold to developers, and the buildings were torn down in 1979.

In 1974, the Watergate scandal became a local reality. Lake Bluff Congressman Robert McClory, representing the Tenth Congressional District, was the second-ranking Republican on the House Judiciary Committee at the time. Originally a staunch Nixon supporter, McClory, after reviewing the "smoking gun" evidence of the White House tapes, was convinced of the president's complicity in the coverup scheme. Taking a nonpartisan position, McClory wrote one of the Judiciary Committee's three articles of impeachment and coauthored another. McClory then took on the role of liaison between Congress and Nixon to negotiate the president's resignation.

In 1975, after decades spent shuffling locations within the uptown area, the Lake Bluff Public Library finally relocated to its present spot at the southeast corner of Oak and Scranton Avenues. A push for the annexation of Knollwood to the village of Lake Bluff in the late 1970s ended in a failed referendum in 1978; another attempt in 1983 failed by three votes; and a final vote in 1996 likewise did not succeed. Much discussion and debate, sometimes acrimonious, preceded all three referendums.

Stonebridge Priory, previously the Kelley estate on Green Bay Road, was sold in 1970 and transformed to the Harrison House, a meeting and conference hotel. This was the first hotel built in Lake Bluff since the camp meeting days. Meanwhile, the new industrial park on the village's western corridor was being developed with new office buildings and small factories. An article in the *Chicago Tribune* stated that Lake Bluff was growing, but officials vowed to retain its "small-town character."[2]

In 1979, the Davis family of Lake Bluff, owners of the Tangley Oaks estate since 1953, sold 160 acres to the James Corporation, a construction company, to develop a new subdivision—the first in the village since the terrace area was built. The proposal, which included the construction of 168 homes, all on cul-de-sacs with large open spaces throughout, was initially met with opposition by some residents who believed that this large development would change the character of the community. Village Board meetings were packed as the development rolled through various stages. By the late 1980s, the Tangley Oaks subdivision was completed, and all the homes had been sold.

In an historic local election in 1982, Phyllis Albrecht, who had previously served as the first female village trustee, was elected as Lake Bluff's first woman president, and she guided the community through the Tangley Oaks controversy. In 1995, she was the chair of the Lake Bluff Centennial Committee, which oversaw the numerous celebrations that were held that year in honor of the village's 100th birthday.

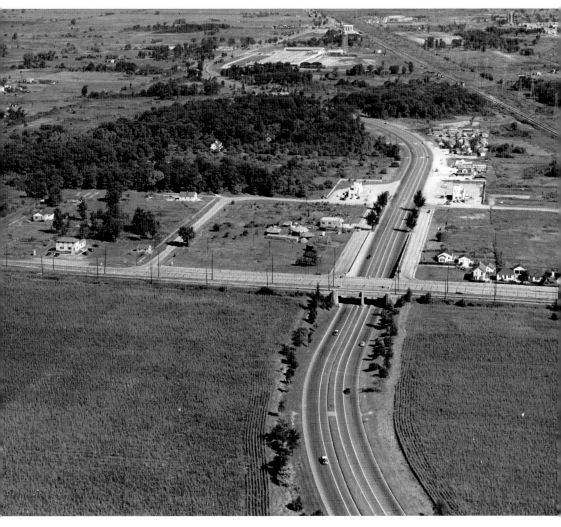

This is an aerial view of the intersection of Route 41 and Route 176 overpass looking north in the early 1950s. The surrounding area was still primarily farmland and open space.

The Terrace. Beginning in the mid-1950s the Chicago Construction Company began building homes in what was called the East and West Terrace area of Lake Bluff on both sides of Green Bay Road. This brochure described the various home models prospective buyers could choose; they ranged from in price from $21,000 to $31,000.

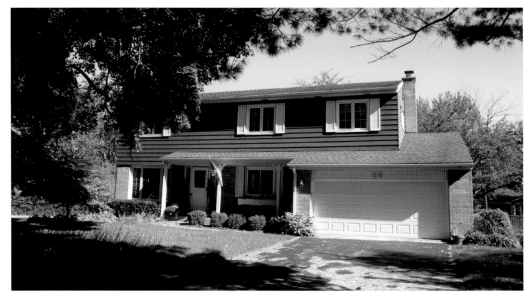

This is 515 Green Bay Road, erected around 1960 as a model for houses the Chicago Construction Company was building in the East and West Terraces. Called the "Monroe," this was the largest and most expensive of the homes. It offered wood-burning fireplaces that could be added in the living room, family room, or basement for an additional cost.

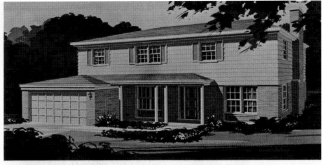

the Special
MONROE

This massive yet graceful Colonial, like the Special Madison, is the largest of The TERRACE homes. Exquisitely designed wood-burning fireplaces may be built in the living room, family room or basement at moderate extra cost.

3,542 Square Feet Under Roof **2,251 Square Feet Actual Living Space**

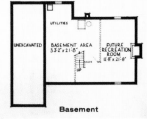

First Floor Plan **Second Floor Plan** **Basement**

Above: In the mid- and late 1950s, Chicago Construction Company began building homes in what was called the East and West Terraces located on both sides of Green Bay Road and south of Route 176. This is taken from a sales brochure given to perspective buyers and showing the largest of the model homes for sale.

Right: More examples of model homes from the Chicago Construction Company's sales brochure.

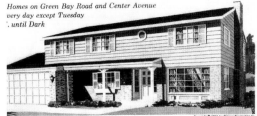

Homes on Green Bay Road and Center Avenue
very day except Tuesday
'. until Dark

Special $**31,700**
adison INCLUDING LOT
low as $4,200 Down
G.I. 29 Year, 5½% Mortgage
low as $5,400 Down
Conventional 25 Year Mortgage

Fifty-five feet long, the beautiful Special Madison has 3,542 Square Feet Under Roof — 2,251 Square Feet of Actual Living Space! • Four double-sized Bedrooms with separate Master Suite • Two ceramic tile Baths and a Powder Room • Floor-thru Living Room • Charming formal Dining Room • Spacious GENERAL ELECTRIC Kitchen with built-ins and full Breakfast Area • Wonderful 16 x 20 Family Room with sliding glass wall to Patio • Attached two-car Garage • Full Basement • Price includes approximately one-quarter acre lot and basic landscaping.

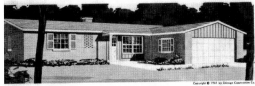

The $**27,700**
ancher INCLUDING LOT
low as $2,800 Down
G.I. 29 Year, 5½% Mortgage
low as $4,600 Down
Conventional 25 Year Mortgage

The all brick Rancher is 54 feet long, and has 1,535 square feet of Actual Living Space! Three twin-sized Bedrooms and two lovely ceramic tile Baths • Tiled Center Hall Entry Foyer • Magnificent Family Room • Separate Dining Room • Big Kitchen has GENERAL ELECTRIC built-in Oven, Range and Fruitwood Cabinets • Breakfast Area • Basement under entire house • Attached two-car Garage • Price includes approximately one-quarter acre lot and basic landscaping.

The
Jamestown $**26,700**
INCLUDING LOT

As low as $2,700 Down
G.I. 29 Year, 5½% Mortgage
As low as $4,400 Down
Conventional 25 Year Mortgage

The lovely classic Jamestown has Three big Bedrooms and loads of Closets • Two ceramic tile Baths plus Powder Room • Kitchen large enough for family dining with GENERAL ELECTRIC built-ins • Beautiful Living Room with bay • Separate Dining Area • Family Room with sliding window wall opening on Patio • Full basement • Attached Garage • 1,610 square feet Actual Living Space! • Price includes approximately one-quarter acre lot and basic landscaping.

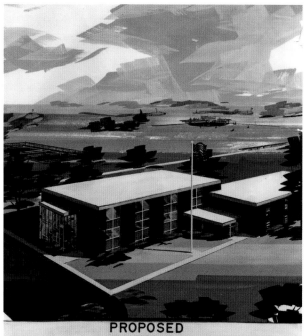

PROPOSED
GREEN BAY ROAD SCHOOL
LAKE BLUFF SCHOOL DISTRICT NO. 65
VIEW SHOWING ROCKLAND PARK
EKSTRAND SCHAD & WEST ————— ARCHITECTS

Left: This 1966 rendition for a new K-6 elementary school on Green Bay Road, along with the 1963 West Elementary School in Knollwood and a junior high building in 1955, were the by-products of the post-war baby-boom-era in Lake Bluff. By 1970, the school population had risen to over 1,200 students housed in three elementary schools and one junior high school.

Below: This picture shows the new elementary school built in 2008 to replace the 1967 Central School.

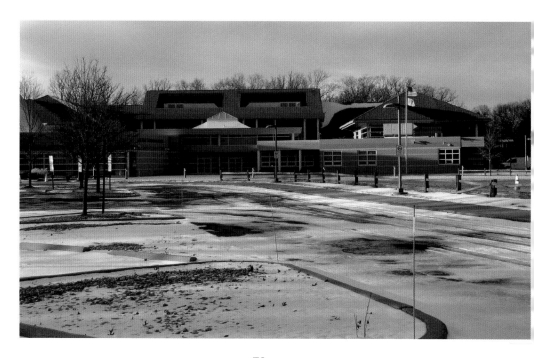

By the 1950s, the Arden Shore Association had changed its mission from a year-round camp for needy and dependent boys to a focus on long term care and the educational needs of "gifted" boys who were unable to cope and flourish in their own home environment. The boys attended the Lake Bluff schools while living on the Arden Shore campus off Sheridan Road.

The administration building of the Arden Shore Association. This was the last building torn down when the property was sold in 1999 and the association's services moved elsewhere in the county.

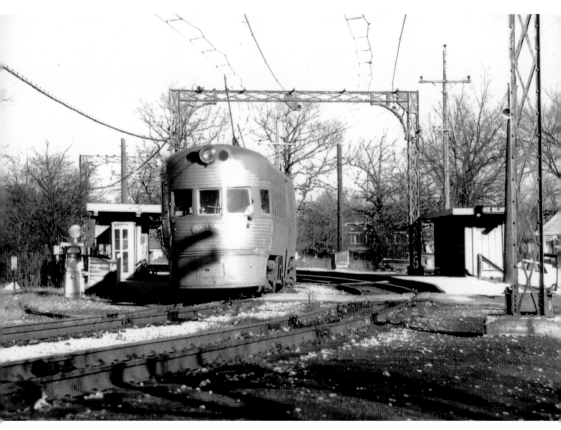

This photo, *circa* 1960, is of North Shore Electric Railroad's spur line train heading west toward Libertyville. The North Shore line made its last run in January 1963 when the railroad went bankrupt. It had been one of the most successful interurban rail systems in the country but could not sustain profitability in the second half of the twentieth century.

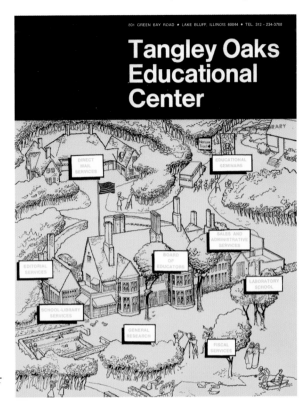

Brochure cover for Tangley Oaks Educational Center, which housed United Educators Publishing Company, publisher of *My Book House* and *Junior Instructor* among other publications. The company was housed in the 1931 Manor House built by architect Harrie Lindeberg for Philip Armour III and purchased by Warren Davis in 1953 for his publishing company. The mansion and grounds housed a major educational resource in the 1960s.

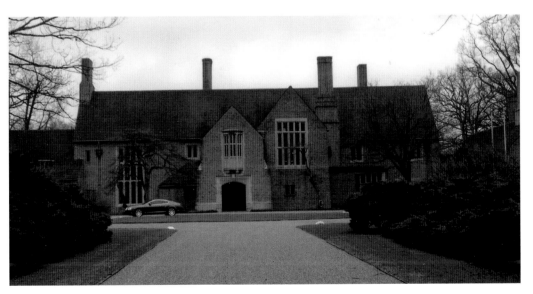

Considered by many to be the finest example of Tudor architecture in America, Tangley Oaks was designed by Harrie Lindeberg in 1931 for Phillip Armour III and his wife. Situated on 161 acres, the house was originally 161 rooms, with 100 closets and fifteen bathrooms. Today, the rooms have been combined into twenty-six rooms and is owned by the Terlato Family, who run Terlato Wines.

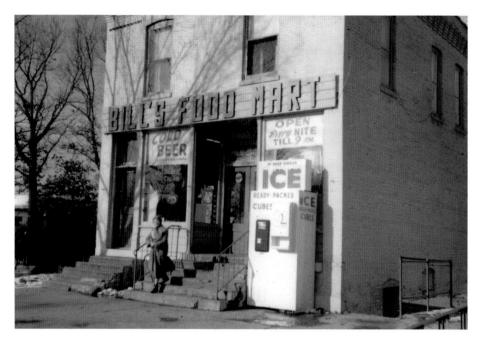

Bill's Food Mart *circa* 1960. Located on the northwest corner of Scranton and Walnut, it is the oldest commercial building in the village built around 1902, replacing an earlier wooden store that burned down.

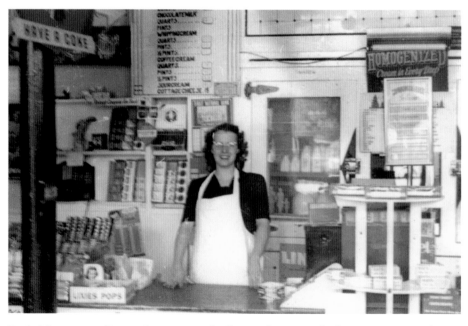

Darla Hansen standing at the counter of Bill's Food Mart in the late 1950s. Owned since the 1950s by Bill and Darla Hansen, it was the "go-to" place in Lake Bluff for groceries and acted as an after-school hangout.

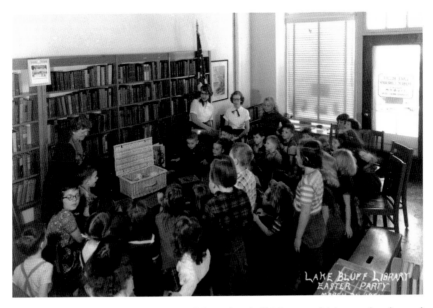

This 1951 photo shows the interior of the Lake Bluff Library, which was then housed in the eastern corner shop of the Griffith Building. The library occupied a space that had previously housed a butcher shop and is now home to Bluffington's Café.

Opened as "Scranton Café" in the mid-1980s by the Karnanzes family as a sandwich and soup restaurant, it replaced a laundromat that had operated in the space for years. Later, after ownership had passed to another owner, the Karnanzes reopened the restaurant as Bluffington's, where it remains a popular eating spot in the village.

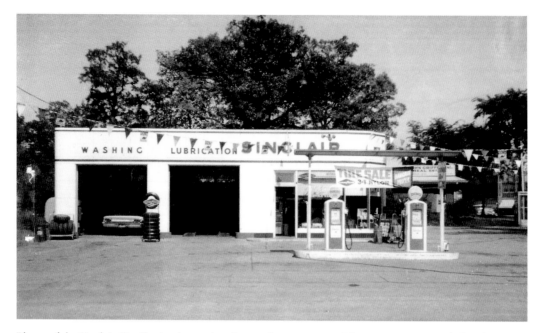

Photo of the Sinclair Gas Station located at the northwest corner of Scranton Avenue and Sheridan Road since the 1940s. This photo was taken around 1960. It remained on that corner pumping gas for village cars for another thirty years. Today, the Lake Forest Bank and Trust occupies that location.

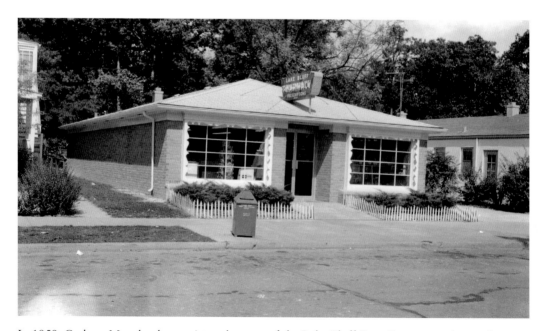

In 1959, Graham Munch, pharmacist and owner of the Lake Bluff Drug Store, turned over the premises to the library and retired. His young assistant, Howard Wilms, built this new brick building directly to the east. In 1979, the Wilms family erected a new two-story pharmacy on the site of the old drug store, which had been torn down after the library moved in 1975.

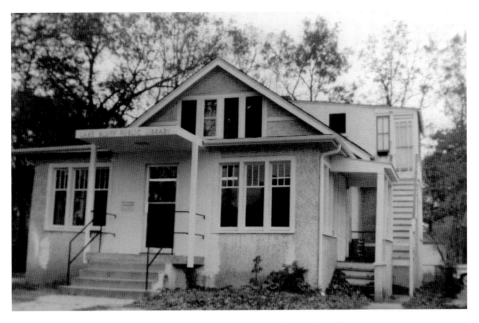

The Lake Bluff Public Library around 1960. Previously, the building was a drug store and home of Graham Munch. He gave the first floor over to the library in 1959 and continued to live on the second floor.

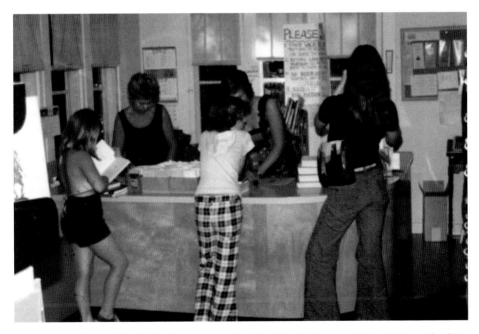

The interior of the Lake Bluff Library 1975, showing Harriet Ernst and Lucy Dalton checking out books to three young patrons on the last day the library was housed in the Munch pharmacy. It shows the circulation desk with young teens, who are displaying the clothing fashion of the times.

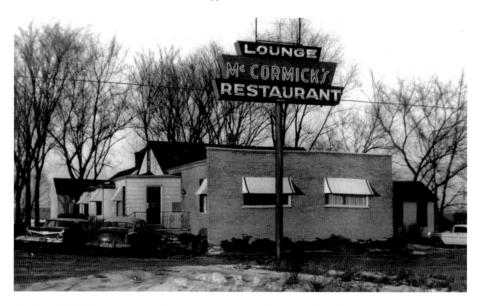

McCormick's Restaurant and Lounge, a popular local landmark from 1954 when it was opened by the McCormick family to its closing in 2009. For decades, when Lake Bluff forbade the sale and consumption of liquor, McCormick's, in the unincorporated area, was the place to gather for a burger and a beer.

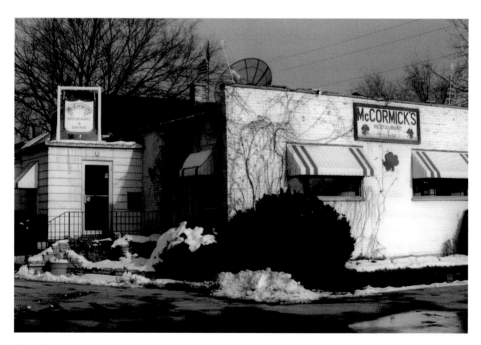

This photo shows McCormick's *circa* 1960. After the McCormick family closed their restaurant in 2009, there was a succession of short-lived eateries that occupied the premises. On February 24, 2019, a fire engulfed the building and it was totally destroyed. At the time of the fire, a boutique furniture restoration and sales business occupied the building.

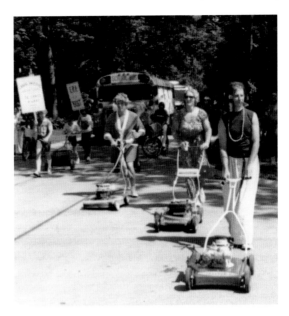

This 1975 photo of the famous Lake Bluff Lawn Mower Brigade, which started in the 1972 Fourth of July parade, continues to this day. Every year, the community looks forward to and anticipates what antics the group will be performing for the 1.6-mile parade.

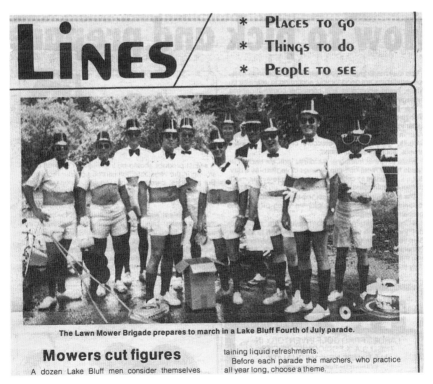

LiNES
* PLACES TO GO
* Things to do
* People to see

The Lawn Mower Brigade prepares to march in a Lake Bluff Fourth of July parade.

Mowers cut figures

A dozen Lake Bluff men consider themselves ... taining liquid refreshments.

Before each parade the marchers, who practice all year long, choose a theme.

When anyone discusses the Lake Bluff Fourth of July parade, the lawn mower brigade is always mentioned, with speculation as what will be the next target of their spoofing. The first generation of "mowers" has given way to another group of Bluffers dedicated to the continuation poking fun and proving there are no "sacred cows."

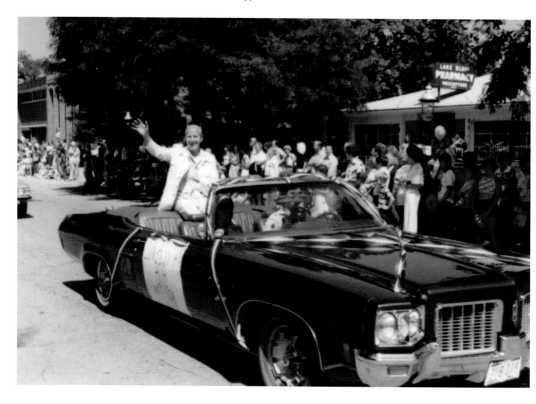

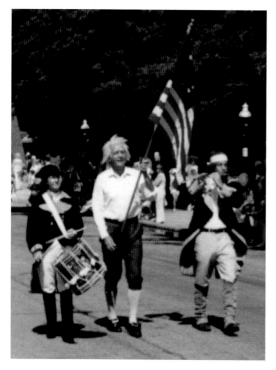

Above: Congressman Robert McClory of Lake Bluff in the 1976 Fourth of July parade. He served as a U. S. Congressman for ten terms from 1962–76 and was a key figure in the Watergate impeachment proceeding against Richard Milhouse Nixon. In 1974, McClory was featured on the cover of *Time* for the significant role he played in the resignation of the president.

Left: For many years, it was a tradition of the Barker family of Lake Bluff to lead the parade in Revolutionary War garb carrying "Old Glory." This photo was taken during the 1976 parade.

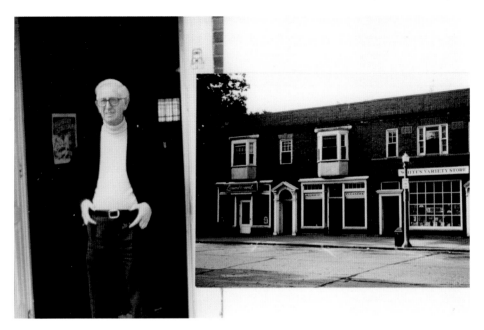

Ralph White, known fondly to hundreds of Lake Bluff kids as "Mr. White," owner of White's Variety Store from 1954 to 1982, a "five and dime" store where all sorts of enticing novelties and candy items could be found. The storefront of White's, located in the Griffith Building on the south side of East Scranton Avenue is shown as it was in the 1970s.

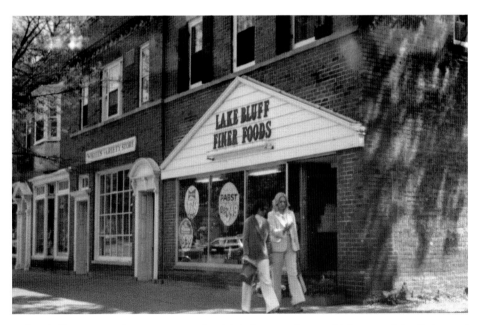

Lake Bluff Finer Foods, successor to the A&P Grocery Store, which was originally located here when the Griffith building was erected in 1925. This photo was taken in late 1970s. The store closed its doors in the 1980s.

Unique North Suburban Property

Make this yours.....

Over 4 Acres of Landscaped Grounds

Seven superbly maintained brick Colonial buildings

**FOR SALE - HOMES FOR CHILDREN CAMPUS
200 SCRANTON AVENUE
LAKE BLUFF, ILLINOIS**

Brochure for the sale of the Lake Bluff Children's Home campus, which covered the entire 200-block area of East Scranton and East North Avenues. The home closed its doors in 1970. When no sale materialized, the buildings were demolished in 1979 and the vacant land was sold to developers for homes.

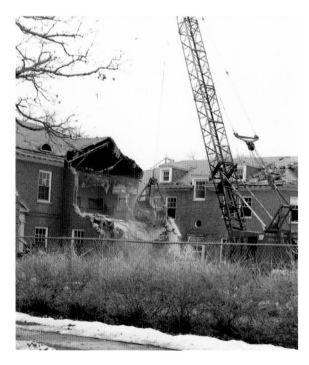

Photo taken in 1979 when the Lake Bluff Children's Home, which had its beginnings in 1894, was torn down to make way for home sites. Prior to the demolition, artifacts from the buildings were sold off to local residents. The four brass chandeliers from the dining hall were rehung in the board room of the Village Hall.

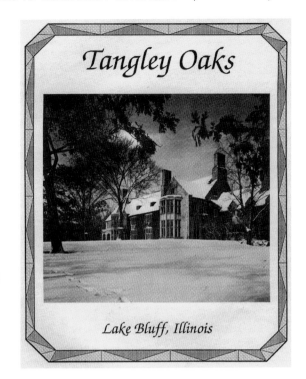

This is the cover for the sales brochure showing the models for the homes offered for in the new Tangley Oaks subdivision. The original Tangley Oaks estate consisted of over 200 acres. In the mid-1970s, 161 acres were sold to the James Corporation who designed 168 homes on cul-de-sacs surrounded by large, open green spaces.

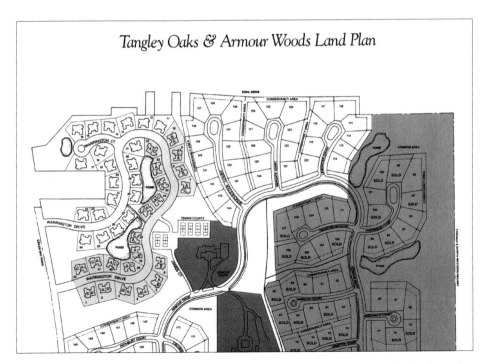

The Tangley Oaks and Armour Woods Land Plan. Taken from the Tangley Oaks brochure, this shows the layout of both the Tangley Oaks homesites and the attached homes in Armour Woods.

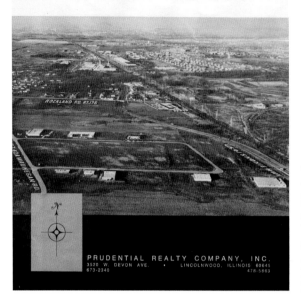

Invest in the
NORTH SHORE INDUSTRIAL & RESEARCH CENTRE
Lake Bluff, Illinois

This brochure from the early 1960s was advertising the new Lake Bluff Industrial Park. This was a new concept for the village to promote business and light industry to take advantage of the economic growth of the period. The park was bounded by Route 176 on the north and the boundary for Lake Forest on the south.

ELCO Mutual Life and Annuity Company relocated to what is now called the Lake Bluff Business Park in 1979 from their previous location in Rogers Park. Dating from their annuity beginnings in 1929, with an insurance business added in 1946, ELCO's move to Lake Bluff helped to fortify Lake Bluff as a new destination for established businesses.

Two firsts: Charles Trusdell, Lake Bluff's first and oldest elected village president. Prominent as a minister for the Camp Meeting Association, he served from 1895 to 1902. His large Victorian home was built in 1889 overlooking Artesian Lake. It still stands today, located directly east of the Public Safety Building.

Phyllis Albrecht was elected the first female president of the village of Lake Bluff. She served from 1981–85. Albrecht headed the Lake Bluff Centennial Committee in 1995; this committee was responsible for the community's celebration of 100 years of incorporation.

The Shoreacres Country clubhouse of one of the 100 best golf courses in America was designed in 1923 by well-known architect David Adler. The golf course was laid out by Seth Raynor, who designed approximately eighty-five courses, including the Augusta Golf Course and the Greenbrier in West Virginia.

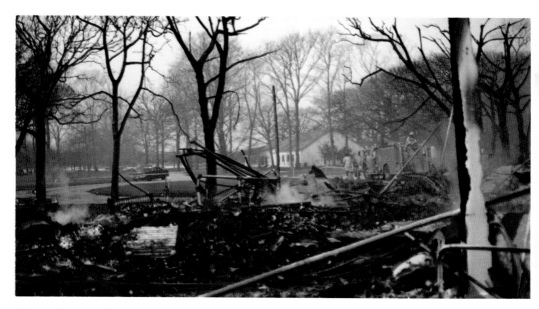

Photo of burning Shoreacres. In 1983, a disgruntled former employee set fire to the clubhouse and destroyed the entire building. In 1984, architect Lawrence Booth, using the original Adler drawings, was able to replicate the original clubhouse.

The First National Bank of Lake Bluff's new building in 1971. Located on the northwest corner of Scranton and Oak, the bank had been established in 1965 and was in existence until 1988 when it was merged with the Northern Trust Bank.

The first Lake Bluff Public Safety Building was erected in 1934 and replaced in 1987 by the current building. It houses our volunteer fire department and the police department, which have both existed since the 1890s.

On July 9, 1991, an old-fashioned train pulled by a steam locomotive traveled through Lake Bluff. This photo captured the wonder and excitement of kids and adults who stood on the station platform to witness a bygone era as it passed through the village.

Johnny Appleseed day at East School 1990. This beloved annual event for the kindergartners in Lake Bluff celebrated the beginning of fall and the magic of the legend of Johnny Appleseed. Like the circus train above, it celebrated a bygone era that is still remembered fondly by Lake Bluffers today.

Celebrations, Challenges and Changes (1995–2020)

The year 1995 saw Lake Bluff's centennial celebrations—fireworks, parties, reenactments, parade, a huge cake, and the Centennial Follies. The community enthusiastically participated in everything. The replacement of the Village Hall tower, which had been removed in 1934 at the height of the Depression when there were no funds to repair it, was the crowning achievement of the centennial celebration. The total cost was financed by donations from residents.

Partially as a result of the centennial celebration, there was a renewed interest in the preservation of Lake Bluff's significant past; this resulted in the formation of a public–private partnership with the village, library, and private donors to build an addition to the library building to house Lake Bluff History Museum and its collection of photographs, artifacts, and documents. The museum was founded in 1982 by two local teachers with the support of long-time Lake Bluff historian Elmer Vliet. Vliet donated his sixty-five-year-old collection of slides, photographs, and other memorabilia. Originally housed in the old library of East School, the museum was later moved temporarily to the closed pharmacy on Scranton Avenue while a permanent home to house the history of the village was sought. The necessary funds were raised, and the new museum annex was dedicated and opened in 2002.

In the late 1990s, a serious controversy arose when the Village Board voted to annex the Sanctuary, composed of 177 single-family homes on 60 acres bordering North Chicago. Residents of the Sanctuary petitioned the village in January 1997 to incorporate the neighborhood into the village limits. This caused serious debate and opposition by some Lake Bluff board members and residents. Annexation passed on a three-to-two board vote.[1] A court battle ensued, questioning the validity of the proceedings. The Illinois Supreme Court finally determined that the annexation was legal.[2]

In 2004, the school district established a strategic plan that included a projection of future facility needs. As a result of the study, and a community engagement process, East School was discontinued as a functioning school building. A decision was made to raze Central School and replace it with a new state-of-the-art elementary school building.

In the spring of 2007, voters approved a $20-million bond issue, by a twenty-vote margin, to build a new school and make renovations at the Middle School. East School was razed in 2011.[3]

Lake Bluff's uptown, by the early 2000s, was greatly diminished as the hub of village commerce and activity. Left were only memories of the drug store, hardware store, White's Variety store, the barber shop, and Finer Foods Grocery. It was said that only the raccoons were on the street after 5 p.m. It was the development of what became known as "Block One," on the north side of Scranton between Sheridan Road and Walnut Avenue, which would spearhead the rebirth of the uptown commercial district. A three-story building was erected, occupied by shops, a brewery, restaurant, and a real estate agency. Offices would occupy the second and third stories. The redevelopment of the south corner of Scranton and Center Avenues into restaurant space around the same time, two coffee shops and a popular sandwich shop helped anchor the uptown as a food and drink destination for the community. The Park District's "Bluffina," numerous block parties, the hosting of the Lake Bluff Bike Criterion Race, and the Lake Bluff's History Museum's annual vintage car show also contributed to the popularity of the uptown as the "place to be."

The Lake Bluff business district, which began as an industrial park in the early 1960s, evolved into what became known as the "Waukegan Road Corridor," with boundaries stretching from the corner of Route 176 and Waukegan Road to the southern limits of the village bordering Lake Forest. It included the Knauz Auto Park and other car franchises bordering Route 41. To stimulate economic growth and an increased tax base, the Village Board conducted a study of the area and restructured zoning and planning ordinances to make that area more attractive to mixed retail, commercial, and office development. As a result, by 2020, the business park included a major retail store, several restaurants, a large grocery store, a well-known garden supply business, and ample office space.

At the beginning of 2020, the village planning to celebrate its Quasquicentennial in September. A newly formed 125 Committee, composed of community volunteers, planned an exciting and ambitious set of activities to commemorate the event, culminating in a huge "Birthday Bash" in September, with bands, food, contests, and ending with a spectacular fireworks display over the golf course in the evening. No one anticipated the COVID-19 pandemic to take over as the main event of the year, postponing some, but not all, planning until 2021. It seemed that the new battle cry, not only of the community, but of the nation became "Masks, Wash Hands, and Safe Distancing," along with the fervent hope that this will soon disappear. The pandemic brought a whole new meaning to the term "Normalcy."

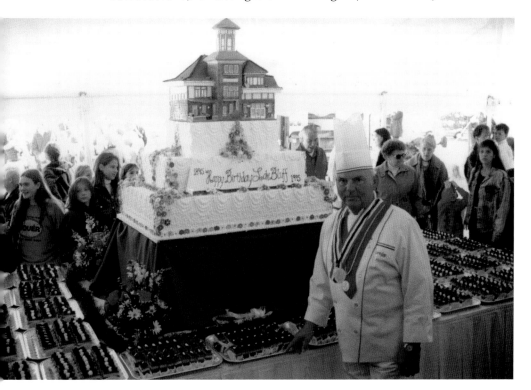

This is a photo of the Centennial Cake made by the Sara Lee Corporation in honor of the 1995 celebration of the 100th anniversary of the incorporation of the village of Lake Bluff.

One of the many events that took place during the village's celebration of its 100th birthday was the Centennial Follies—three evenings of entertainment of skits and songs with over 200 local residents participating on the Lake Forest High School stage. This photo show member of the Lake Bluff Women's Club in a song and dance routine.

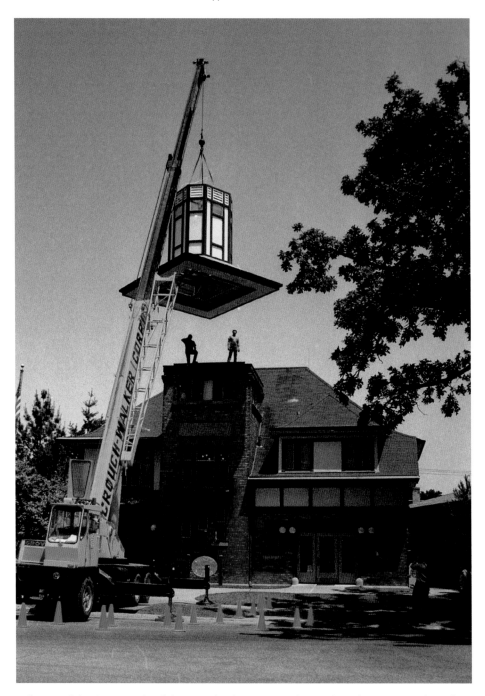

In honor of the Centennial Celebration, funds were raised to replace the tower on the Village Hall. In 1934, the original stucco tower had been removed. It needed repairs, and the village, in the midst of the Depression, could not afford to fix it. By replicating the old tower, the architecturally significant Village Hall was restored to its original look in 1905 when it was built.

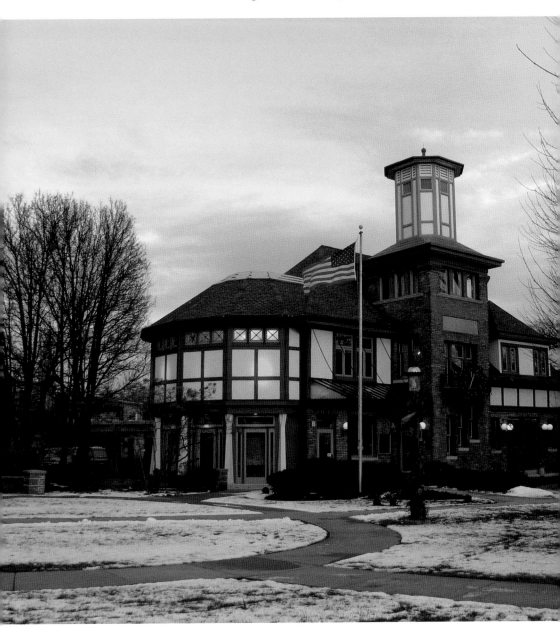

In 1998, an addition was built on the northwest side of the Village Hall, which expanded the meeting space on the second floor and added a conference room on the first floor. This was done to reflect the expanded needs of the village due to the increase of population and businesses.

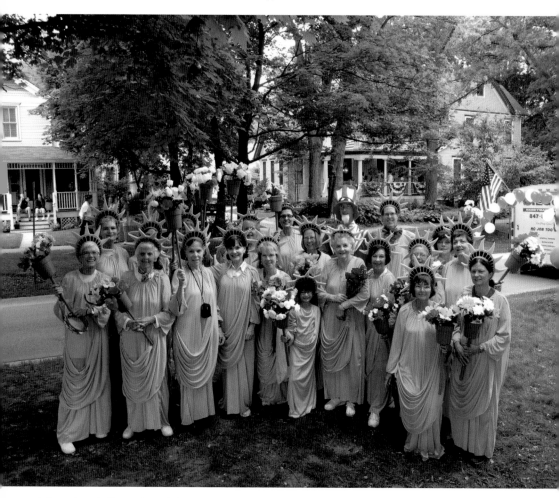

The Lake Bluff Garden Club members all costumed as Lady Liberty for their entry in the annual Fourth of July Parade in 2009. The club was founded in 1917 with the focus on civic beatification, conservation, wildlife protection, and enhancing Lake Bluff as a special place to live.

Opposite above: In 1995, as part of the village's centennial celebration, the Lake Bluff Schools each took a photo of all students and faculty in front of the school with all the students present. This is the photo taken in front of the East School, the built in 1895. There were two additions added in 1946 and 1950; it was demolished in 2011.

Opposite below: Kindergarten students at East School around 2005. The school began as a four-room school in 1895 with additions added in 1922, 1946, and 1950; it was razed in 2011 after serving generations of Lake Bluff children.

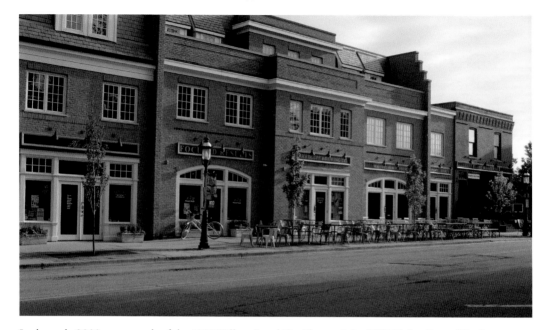

In the early 2000s, as a result of the 1997 Village Land Use Plan and the 1998 Teska Central Business District Plan, the area known as Block One was developed. Bounded by Sheridan Road, North, Scranton, and Walnut Avenues, it was three stories high and included retail and commercial office space. In many ways, it heralded the renaissance of Lake Bluff's uptown.

Lake Bluff's Rib Fest, an annual event held since 2002 on the village green, is one of the many activities that have hallmarked the renaissance of the village's uptown and attracts thousands every year. Local teams compete against each other to grill the tastiest ribs to receive "Best Ribs" honors.

In 2002, after a successful fundraising effort by the community through an intergovernmental agreement with the history museum, the library, and the village of Lake Bluff, an addition was built to the existing library to provide a new home for the history museum's collection. This collaboration with local governmental entities has proven to be an excellent model for community cooperation.

This is an interior photo of the Lake Bluff History Museum. Originally located in 1982 on the second floor of the then-closed East School, by 2002, the museum was in its permanent location next to the Lake Bluff Library. The museum archives contain artifacts, photos, documents, and other memorabilia dating to the first beginnings of Lake Bluff.

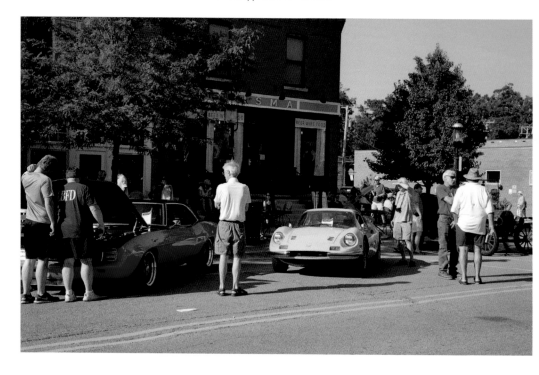

Above: Another annual event is the June Antique Auto Show, sponsored by the Lake Bluff History Museum. It draws over 100 classic cars to our uptown streets, with owners showing off their beauties and competing for "Best in Show."

Left: The Lake Bluff History Museum also conducts walking tours of Lake Bluff during the year. They are popular events that bring people together to learn about and explore the village's history.

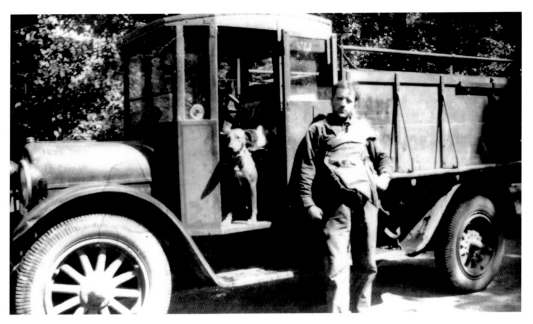

The Lake Bluff Ice Company truck with iceman Stephen Meutescu. He delivered ice cut from local lakes during the winter to residents in town for almost twenty years during the 1930s and '40s.

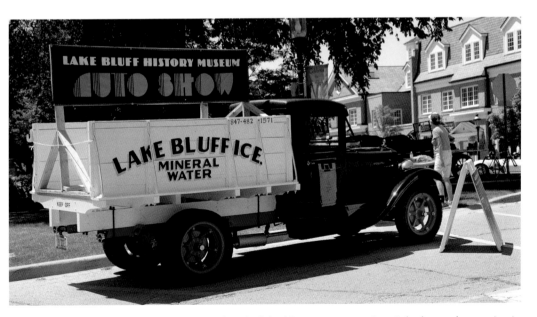

The original 1931 Lake Bluff ice truck, which had been in storage since it had ceased operating in the 1940s, was brought back to the village in 2009. The Lake Bluff History Museum, with several volunteers, undertook the restoration of the vehicle—$30,000 and thousands of volunteer hours later, the restoration was completed and the truck was proudly driven in the 2013 Fourth of July Parade. Since then, it had proudly represented the history museum and the village in community events and celebrations.

The development of the original Lake Bluff Industrial Park into a mixed-used business park transformed what became known as "the Waukegan Corridor." A new Target store replaced a closed auto dealership in 2013. Other retail stores and restaurants soon followed.

This photo of the Chevy Exchange located in Lake Bluff off Route 41 is the successor to the old Shepard Chevrolet, which, for many years, was located on the site of the present-day Target.

The south side of Waukegan Road saw several new businesses coming to Lake Bluff. Pasquesi Home and Garden is one of the more prominent ones that added a more upscale look to the area.

In 2014, an upscale Heinen's Grocery Store, originally from Cleveland, Ohio, opened in what was previously a closed Dominick's Grocery store, helping to revitalize the commercial corner of Route 176 and Waukegan Road.

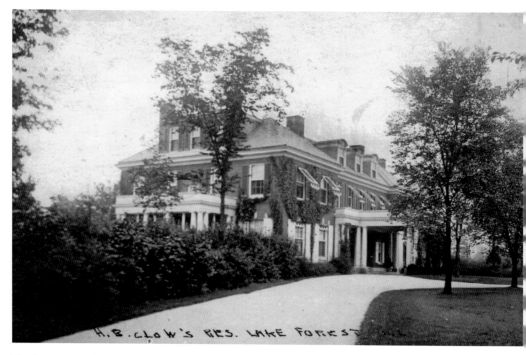

The last twenty-five years has seen the breakup of several of the large Lake Bluff estates built in the early 1900s. Lansdowne was built for the Clow family in 1911 by Chicago architect Benjamin Marshall. Originally 23 acres on the lakefront, with gardens designed by renowned landscape architect Jens Jensen, the estate was subdivided into seven homesites and the manor house.

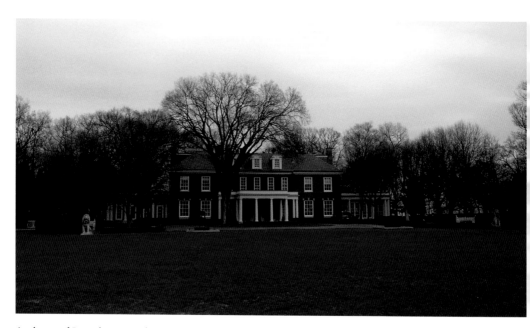

A photo of Lansdowne today.

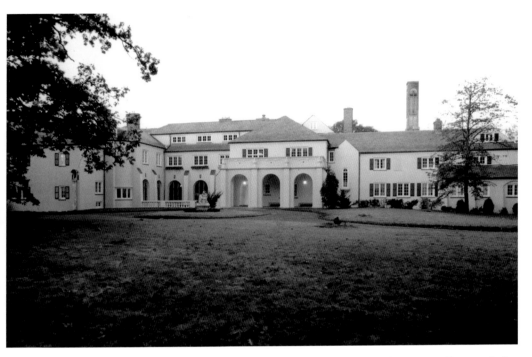

In 1916, William Kelly, a Chicago steel magnate, commissioned Howard Van Dorn Shaw to design a country estate for his family. "Stonebridge" was originally built on approximately 130 acres on what was the Michael Mines farm on Green Bay Road. Jens Jensen, a well-known landscape architect, was hired to plan the gardens. In the 1940s, the Servite priests bought the estate, added a chapel and dormitories, and made it a monastery and retreat house. In the 1980s the manor house was purchased by a company who turned the property into a conference center and hotel named "Harrison House." In 2006, having shrunk to less than 40 acres, "Stonebridge" was purchased by a developer who proposed to retain the mansion and gate house and build eighty-five single-family homes as a planned residential development (PRD). When that developer was unable to fulfill his financial requirements, the estate was sold again with the same PRD intact. Currently, in 2020, the PRD is in dispute with ongoing litigation, with the future of the manor house and gatehouse in doubt.

This postcard shows Lake Bluff Junior High School soon after it was open in the fall of 1955. Originally housing all the seventh and eighth graders of Lake Bluff, it was built adjacent to the campus of the Lake Bluff East School. The school was built as a result of the influx of students during the baby boom years.

In 2016, there was a major renovation to Lake Bluff Middle School. The school was built in 1955 with several later additions. This newest renovation modernized the school to better equip student learning needs for the twenty-first century.

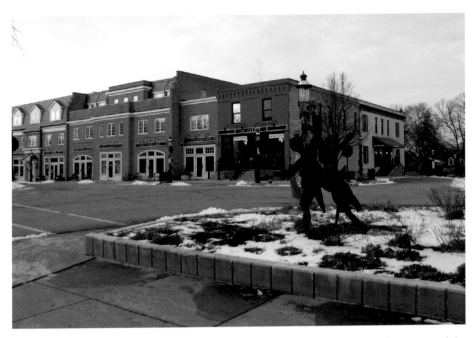

Uptown Lake Bluff during the winter holiday season, showing off the transformation of the village from its earlier less prosperous days to what it is now—a vibrant, welcoming community.

This photo shows the former site of Wisma, now Be Market, located in the original 1902 Rosenthal and Helming grocery store. It is the oldest commercial building in the uptown area.

As part of Lake Bluff's holiday celebrations, the Village Hall is highlighted with colorful spotlights that sets off its prominent entrance to the uptown area.

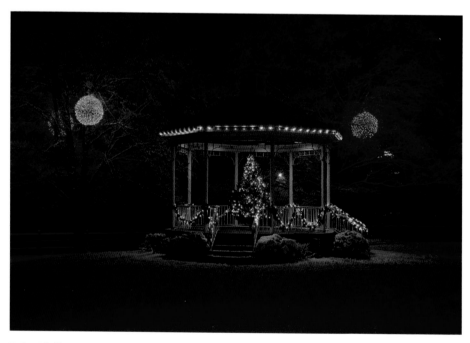

Lake Bluff's iconic gazebo, all lit up for the holidays, is surrounded by the unique colored orbs that have become a yearly tradition included as part of the festivities. The lighting of the village green signifies the beginning of seasonal celebrations for the community.

Above: The Lake Bluff Garden Club originally adopted a neglected overgrown lot at the corner of Sheridan Road and Washington Avenue. They created a garden there in honor of the 1995 Lake Bluff Centennial and have maintained it ever since. The garden was restored under the guidance of the club in 2020 for the 125th anniversary of the village.

Right: To advertise the celebration of the 125th birthday of Lake Bluff, a postcard mailing was sent out to the community listing some of the major activities that would be happening in 2020.

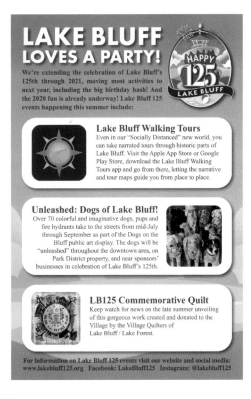

LAKE BLUFF LOVES A PARTY!

We're extending the celebration of Lake Bluff's 125th through 2021, moving most activities to next year, including the big birthday bash! And the 2020 fun is already underway! Lake Bluff 125 events happening this summer include:

Lake Bluff Walking Tours
Even in our "Socially Distanced" new world, you can take narrated tours through historic parts of Lake Bluff. Visit the Apple App Store or Google Play Store, download the Lake Bluff Walking Tours app and go from there, letting the narrative and tour maps guide you from place to place.

Unleashed: Dogs of Lake Bluff!
Over 70 colorful and imaginative dogs, pups and fire hydrants take to the streets from mid-July through September as part of the Dogs on the Bluff public art display. The dogs will be "unleashed" throughout the downtown area, on Park District property, and near sponsors' businesses in celebration of Lake Bluff's 125th.

LB125 Commemorative Quilt
Keep watch for news on the late summer unveiling of this gorgeous work created and donated to the Village by the Village Quilters of Lake Bluff / Lake Forest.

For information on Lake Bluff 125 events visit our website and social media:
www.lakebluff125.org Facebook: LakeBluff125 Instagram: @lakebluff125

A highlight of the 2020 Quasquicentennial of Lake Bluff was the "Dogs on the Bluff," a public art display in Lake Bluff featuring canines of the fiberglass variety, sponsored by the 125 Committee and the Lake Bluff History Museum. Over seventy dogs and a couple of fire hydrants were sponsored and painted by locals and displayed throughout town.

Opposite above: This photo of the Lake Bluff 125th anniversary quilt was on display as part of the Lake Forest Art Stroll 2020. The quilters, left to right, are: Alice Hutchison, Kate Klein, Ann Grant, and Marti Austin. This quilt was made by the village quilters of Lake Bluff and Lake Forest to commemorate Lake Bluff's 125th anniversary.

Opposite below: Eating in parking lot—during the COVID-19 pandemic of 2020, the village, to accommodate local eating and drinking establishments, sectioned off the south side of East Scranton Avenue across from the village green, to expand outside eating areas for customers.

ENDNOTES

Chapter One

1 Willard, *Glimpses of Fifty Years: The Autobiography of an American Woman* (Chicago: Woman's Temperance Publication Association, 1889), p. 376.
2 Jensen and O'Hara, *Lake Bluff*, Postcard History Series (Charleston, SC: Arcadia, 2008), p. 9.
3 *Ibid.*

Chapter Two

1 U.S. Department of Commerce, Bureau of the Census, *Fifteenth Census of the United States: 1930*, vol. I (Washington: U.S. Government Printing Office, 1931), p. 299.
2 U.S. Department of Commerce, Bureau of the Census, *Sixteenth Census of the United States: 1940*, vol. I (Washington: U.S. Government Printing Office, 1942), p. 302.

Chapter Three

1 U.S. Department of Commerce, Bureau of the Census, *Census of Population: 1950*, vol. I (Washington: U.S. Government Printing Office, 1952), 13-9; U.S. Department of Commerce, Bureau of the Census, *1970 Census of Population: United States, Alabama to Mississippi*, vol. I (Washington: U.S. Government Printing Office, May 1972), pp. 15–16.

Chapter Four

1 Nelson, "A History of the Lake Bluff Schools," Lake Bluff Schools District 65 (website), History of District 65, accessed October 10, 2020, lb65.org/about/history.
2 "Why is Knollwood Unincorporated?" Knollwood Neighbors (website), Knollwood Facts, accessed October 10, 2020, knollwoodneighbors.org/why-is-knollwood-unincorporated.html.

Chapter Five

1 Grano, "Lake Bluff Backs Sanctuary Annexation," *Chicago Tribune* (August 11, 1998).
2 People ex rel. Graf *v*. Village of Lake Bluff, 206 Ill. 2d 541, 795 N.E.2d 281 (2003).
3 Nelson, "A History of the Lake Bluff Schools."

BIBLIOGRAPHY

Grano, L., "Lake Bluff Backs Sanctuary Annexation," *Chicago Tribune* (August 11, 1998).

Jensen, L. and O'Hara, K., *Lake Bluff*, Postcard History Series (Charleston, SC: Arcadia, 2008).

Nelson, J., "A History of the Lake Bluff Schools," Lake Bluff Schools District 65 (website), History of District 65, accessed October 10, 2020, lb65.org/about/history.

People ex rel. Graf *v*. Village of Lake Bluff, 206 Ill. 2d 541, 795 N.E.2d 281 (2003).

U.S. Department of Commerce, Bureau of the Census, *Fifteenth Census of the United States: 1930*, vol. I (Washington: U.S. Government Printing Office, 1931).

U.S. Department of Commerce, Bureau of the Census, *Sixteenth Census of the United States: 1940*, vol. I (Washington: U.S. Government Printing Office, 1942).

U.S. Department of Commerce, Bureau of the Census, *Census of Population: 1950,* vol. I (Washington: U.S. Government Printing Office, 1952), 13-9; U.S. Department of Commerce, Bureau of the Census, *1970 Census of Population: United States, Alabama to Mississippi*, vol. I (Washington: U.S. Government Printing Office, May 1972).

Willard, F. E., *Glimpses of Fifty Years: The Autobiography of an American Woman* (Chicago: Woman's Temperance Publication Association, 1889).